Judith Kerr

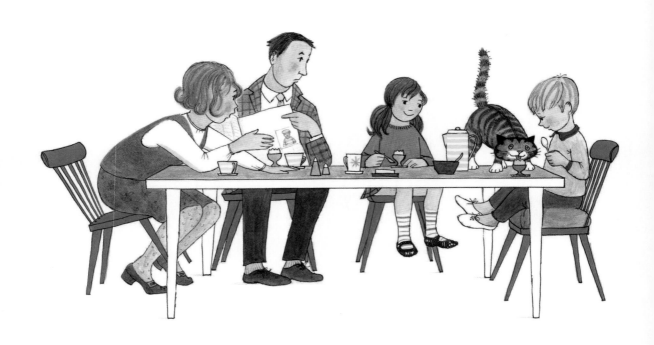

Joanna Carey

THE ILLUSTRATORS

Judith Kerr

SERIES CONSULTANT QUENTIN BLAKE
SERIES EDITOR CLAUDIA ZEFF

WITH 103
ILLUSTRATIONS

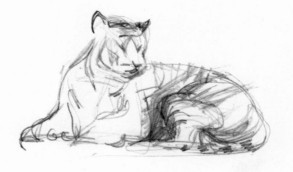

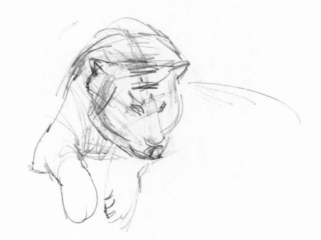

FRONT COVER Illustration from *The Tiger Who Came to Tea* (detail), 1968
BACK COVER Judith Kerr, 2007, photographed by Sam Pelly © Sam Pelly

FRONTISPIECE The Thomas family and Mog from *Mog the Forgetful Cat*, 1970
ABOVE Sketches of tigers, *c.* 1967
PAGE 112 Illustration from *The Tiger Who Came to Tea*, 1968

First published in the United Kingdom in 2019 by
Thames & Hudson Ltd, 181A High Holborn,
London WC1V 7QX

Reprinted 2022

Judith Kerr © 2019 Thames & Hudson Ltd, London
Text © 2019 Joanna Carey
Works by Judith Kerr © 2019 Kerr-Kneale Productions Ltd

Designed by Therese Vandling

British Library Cataloguing-in-Publication Data
A catalogue record for this book is available from the British Library

Library of Congress Control Number 2019932291

ISBN 978-0-500-02215-3

Printed and bound in China by C&C Offset Printing Co. Ltd

MIX
Paper from
responsible sources
FSC® C008047

Be the first to know about our new releases, exclusive content and author events by visiting
thamesandhudson.com
thamesandhudsonusa.com
thamesandhudson.com.au

CONTENTS

Introduction

Judith Kerr was in her forties when she sprang to prominence in 1968 with publication of her first book, *The Tiger Who Came to Tea*, and since then has produced other books that have also become classics of children's literature, including *When Hitler Stole Pink Rabbit* and *Mog the Forgetful Cat*.

Born into a cultured family in Berlin, Kerr was only 12 when she came to Britain in 1936 as a refugee and in her eventful life, in addition to her forty or so children's books, she has worked as a textile designer, art teacher, painter, television scriptwriter and written novels. She speaks German, French and English, but ever since she was a very small child, drawing has been her first language.

Childhood in Germany, Switzerland and France

Kerr's early life had all the ups and downs of a fairytale. It is the story of a family forced by an evil regime to flee their home and to set out on an arduous quest that would see them living as refugees, travelling through countries not their own, their happiness and well-being continually threatened by poverty, danger and uncertainty. For Alfred Kerr and his wife, Julia, it was a terrifying, unsettling time, but for their children, Michael and Judith, whom they heroically protected from the truth for as long as possible, it was a huge adventure.

Judith was born in 1923 in Berlin to a German-Jewish family. Her father, then 55, was a well-known writer, journalist, poet and influential theatre critic who had married Julia Weismann, a composer thirty years his junior, in 1920. Julia's father, Robert Weismann, was Secretary of State of Prussia, 1923–32. Alfred became a fearless and outspoken critic of the rising Nazi party and it was his contempt and mockery of Hitler that led to his having to flee the country early in 1933. Luckily someone tipped him off that his passport was about to be seized, and he escaped immediately. His works were among the books publicly burnt as being 'un-German' in May that year and he was

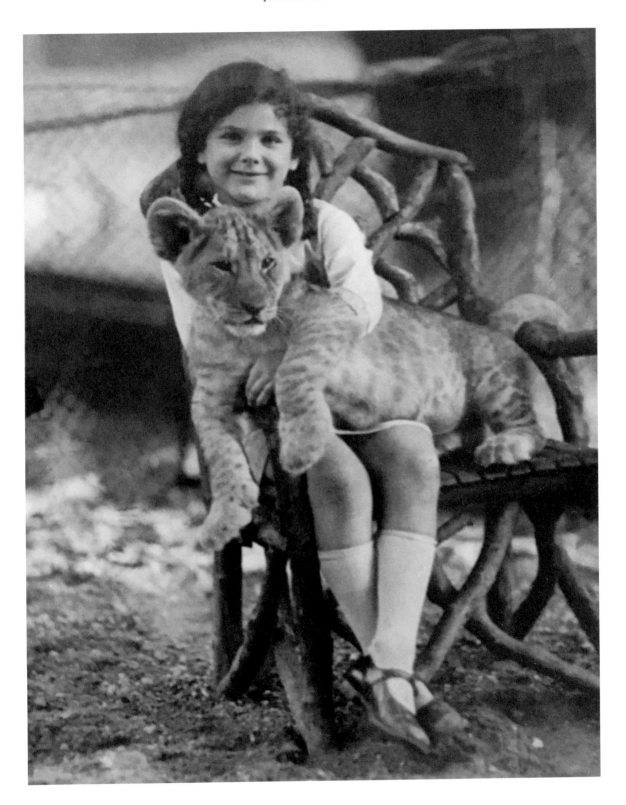

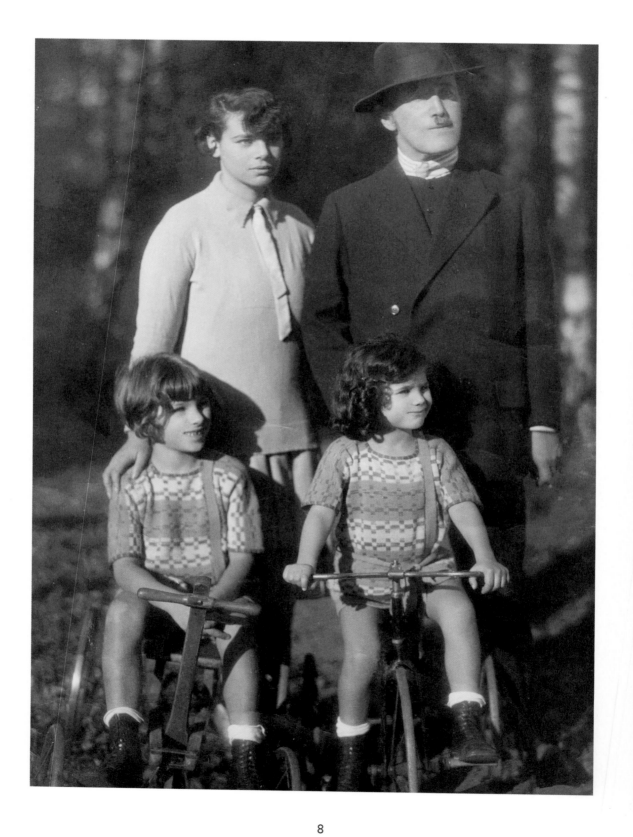

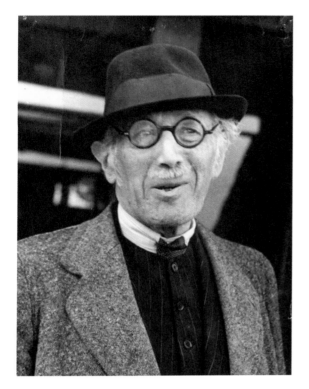

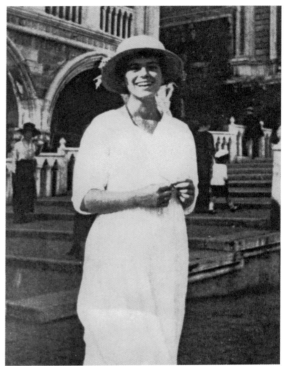

OPPOSITE
Julia and Alfred Kerr with
Michael and Judith, 1928

ABOVE LEFT
Alfred Kerr

ABOVE RIGHT
Julia Kerr on her honeymoon
in Venice in 1920

OVERLEAF
An early drawing depicting the
Kerr family in Switzerland, *c.* 1933

deprived of his German nationality. This was disastrous:
as a writer, it meant that he lost everything – home, income,
security and reputation, and ultimately the very language
he wrote in. It was a dark, desperate period, not only for him
but also for Julia, who was a spirited and emotional woman.
Following Alfred's sudden, secret departure, it was she who
had to cope with the children and the house, packing up
what she could of their belongings before they too fled Nazi
Germany without letting anyone know their plans. They
subsequently found out that the Nazis had arrived at their
house the day after they left to confiscate their passports.
It was a narrow escape.

Space was limited and Judith could take only one soft
toy: her real favourite was her pink rabbit, but on an impulse
she chose instead a black dog, because she had not had it
long and had hardly played with it. She also took a book
given by some school friends, *They Grew to be Great*, which
told the story of famous people who had survived 'difficult
childhoods', and this phrase resonated in her mind as the

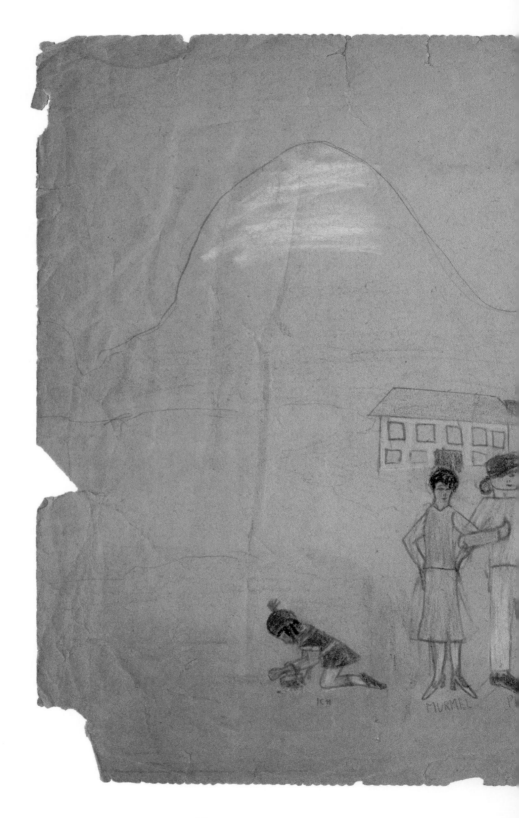

train took her away. Having successfully, but nervously, concealed their identity as they crossed the German border, the family, though now thankfully reunited in Zurich, found themselves far from home, and nearly penniless.

Then, her father encountered difficulties in getting his work published in Switzerland because the authorities were keen to keep in with Hitler, despite their official neutrality. So after a few months there the family made its way to Paris. Alfred, fluent in French, found some work, particularly for the *Pariser Tageblatt*, a paper for German refugees, but, now aged 65, life was not easy for him or Julia. Judith, however, loved the city, was quick to learn French, and was soon top in her class, hearing herself referred to as 'that clever little refugee girl'. Being a refugee appealed to her; it seemed to offer her and her brother, who was two years older, a far more interesting childhood than they would otherwise have had. And as for learning a new language, she later observed that 'it's no problem at that age – you simply want to be like everyone else'.

OPPOSITE

The cover artwork for *When Hitler Stole Pink Rabbit*, published by Collins in 1971

BELOW

Chapter headpiece from *When Hitler Stole Pink Rabbit*, 1971

Kerr wrote movingly about these experiences in *When Hitler Stole Pink Rabbit* (1971), the first of three semi-autobiographical novels, collectively known as *Out of the Hitler Time*, which show her to be an engaging, perceptive writer with a dry, subtle wit. The first volume, still used as a set text in German schools as it offers an accessible way of talking about life under the Nazis, is a shockingly truthful, but often funny and heart-warming account of the family's escape from Germany and their life as refugees. Kerr's illustrated chapter openers are in monochrome – dark, descriptive line drawings with a lot

ABOVE
Chapter headpiece from *When Hitler Stole Pink Rabbit*, 1971

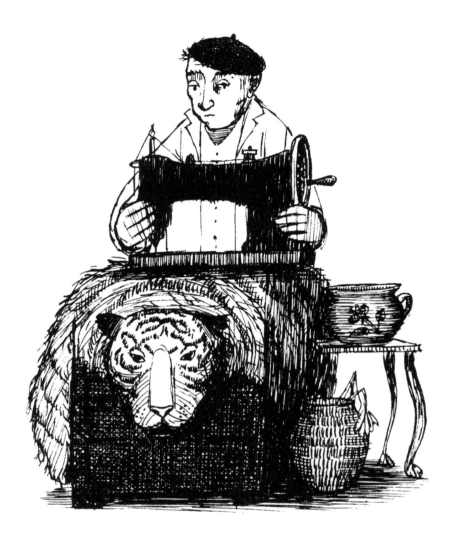

Chapter headpiece from *When Hitler Stole Pink Rabbit*, 1971

of vertical black hatching that adds to the drama as the impoverished family travels from one country to another. Writing about their stay in Paris, Kerr remembers the time her father bought an ancient sewing machine in a flea market, planning to save money by getting his wife to mend the family's clothes. However, Julia, being totally impractical, did not have those skills, and in any case the sewing machine was not only broken, but also totally irreparable. The drawing for that chapter strikes a wistful note, showing the useless antique sewing machine sitting, as it had been in the market, on a mournful-looking tiger-skin rug.

Early drawings

Even as a small child, Kerr made it clear to everyone that drawing was her passion and she spent all her time at it. In her autobiography, *Creatures* (2013), Kerr gave a child's eye view of what passed for a drawing lesson in her kindergarten in Berlin.

The kindergarten fräulein plonked a flower down in the middle of the table and said, 'Today we are all going to draw a tulip.' I looked at the tulip. There seemed to be a lot of curved bits, which I did not yet know were called petals, so I drew one. But when I looked up from my drawing it no longer looked the same. It had shifted sideways and looked narrower, so I changed it and drew the one next to it, and then another and another and another. But each time I looked up they shifted again and I was trying to remember which ones I had drawn and which were still to do, when the kindergarten fräulein appeared beside me. 'What on earth are you doing?' she said. 'Don't you know how we draw a tulip?' 'This is how we draw a tulip.'

The fräulein's use of the word 'we' was chilling, as was the soulless, schematic representation of a tulip that she drew. Kerr was baffled by this approach to something so complex and mysterious, and it was twelve years before she considered drawing from life again.

Luckily the tulip incident did not put her off her own sort of drawing. Nothing could have done that. She knew with certainty that she was going to be an artist and she cannot remember a time when she did not love drawing; from the moment she first picked up a pencil, she was completely absorbed. Kerr likens it to the way her brother felt about football: it came naturally to him to be constantly kicking a ball around. It was the same for her with her drawing.

Julia recognized and encouraged her daughter's talent early on, and was fiercely proud of her. When preparing

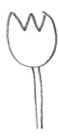

ABOVE
Drawing of a tulip as demonstrated by Kerr's kindergarten teacher

to go into exile, in addition to dealing with the rest of the family's needs, Julia managed to gather a number of her daughter's drawings and pack them safely in the suitcases that would accompany them on their travels into the unknown. Thanks to her mother's extraordinary prescience, Kerr was fortunate to retain a cache of her early work, now housed in the archive of Seven Stories, the UK's National Centre for Children's Books in Newcastle upon Tyne.

These carefully preserved artworks, alive with movement and detail, offer a unique insight into Kerr's childhood. They are all drawn from her imagination, fuelled by her prodigious powers of observation and memory, still the key elements of her creative method. She clearly had an instinctive, purposeful approach to planning and composing a picture, and it is interesting to see how sensitively she drew each individual character, often seeming to challenge

BELOW

A mountainous view of Holland, drawn from Kerr's imagination, c. 1935

OVERLEAF, LEFT AND RIGHT

Compositions in French and English, written after Kerr arrived in England in 1936

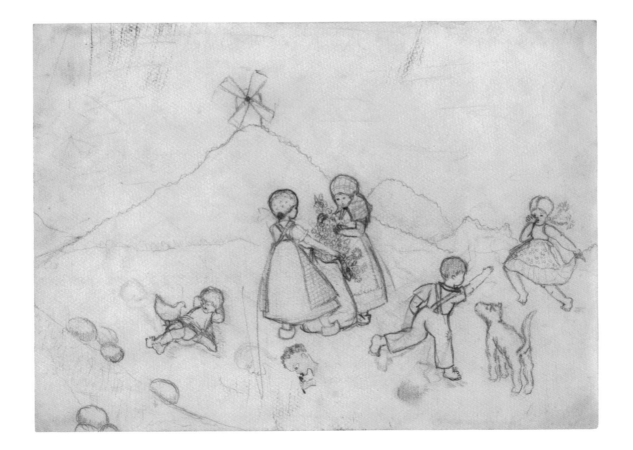

Silence !

Votre professeur, un grand homme vigou‑reux avec (hélas) de très bons poumons, engueule sa classe : "C'est a‑bo‑mi‑nable! C'est trop! J'en ai assez! Je vous reporterai à Monsieur le Directeur. Vous aurez 100 lignes! 200 lignes! 300 lignes! Il sera retenu, ce garçon insupportable! impoli! indiscipliné! Cet enfant stu‑pide! Ce phénomène de

f2

A Fir-tree, a Lady-bird and a Toad-stool

"Yes," said the lady-bird, "isn't it a simply horrid summer?" The lady-bird was sitting on a toad-stool.

"Horrid?" asked the toad-stool. "Horrid??? It's a lovely, beautiful, splendid, nice and wet summer."

"Wet!" said the fir-tree. "It certainly is wet. But it certainly is not a nice summer. Why, I am dripping wet, and simply can't

herself with the complex poses she chose for them, and then disposing them across the page to maximum effect. Kerr was always reluctant to leave a drawing until she was satisfied with it. One can see that even then she indulged in quite a bit of rubbing out; she had to get it right.

Kerr always liked to work alone, undisturbed by others; she was the only one in the family who liked to draw, it was *her* thing, an intensely personal activity to which she devoted most of her time. And because, after leaving Germany, the family moved about frequently, the actual fabric of the artwork varies a little, according to where they were living. Kerr remembers being ill in bed in Switzerland, and her mother wanting to buy her a present. Because a gift for her daughter usually meant a new drawing book, Julia went (unwittingly) to a professional artists' supplier and bought a costly block of the finest quality watercolour paper. In the Seven Stories' archive it is possible to see, from the quality of the paper, which works benefitted from her mother's unintentional extravagance in the art shop that day.

One effect of their peripatetic but always interesting life was that Judith and her brother went to at least ten different schools. Highly motivated, articulate and always knowing her own mind, she was probably not the easiest child to teach. At one school, in Berlin, the art teacher wanted the class to paint a hot-house full of flowers, which led to a discussion about how to mix a range of different colours. For flesh tones, the teacher suggested mixing crimson and yellow: 'Crimson!!' exclaimed Kerr in surprise. 'Really? Are you *sure*? *I* would use vermilion.' Being small for her age, and looking younger than the other children, one can imagine that this rather precocious remark was not well received.

One teacher had certain progressive theories about art education and 'child art', advocating an emotional rather than a descriptive approach. 'But I just wanted to paint things the way *I* saw them,' Kerr says rather wearily. So she 'resigned' from that class. Another teacher, serious and well meaning, decided that Kerr would benefit from learning to draw hands accurately: she taught with the aid of a valuable collection of plaster-cast hands, taken from

classical statuary. But Kerr would not even look at these: 'I don't want to be *told* how to draw hands,' she said, quite reasonably. 'I'd rather find out for myself.' And so she did, with increasing success. Throughout her work the hands she draws are always very well observed: capable, confident and expressive. (A good drawing can be undermined by poorly drawn hands, and for that reason, to this day, when she is drawing, Kerr always keeps a small mirror beside her, for reference, just to be sure.)

The one thing she really did want to learn at that time was how to show children on the move. She liked to draw lively outdoor scenes, but was increasingly frustrated by the fact that, however hard she tried, her children never looked as though they were really running. Desperate to help, her mother arranged for Kerr to talk to a family acquaintance, the German-Jewish painter Max Liebermann. He was the

BELOW
Pencil and watercolour drawing,
c. mid-1930s

real thing and she liked him; he did not talk about ancient plaster casts. After looking thoughtfully at her drawings, he told her the problem was that her running children always had their feet flat on the ground. Liebermann patiently explained that when you run, you lean forward on to your toes. He showed her the way the foot moves, how and where it bends and flexes. This was a success and Kerr overcame her customary reluctance to accept help, and thereafter her figures developed a real spring in their step, particularly in the many pictures she did that involved dancing.

Kerr went to dancing classes from an early age and was noted, even at the age of 5, for the spectacular high kicks she achieved in the can-can. Later she and her friends would join hands for circle dancing – a form of dance that has inspired artists through the ages, including Henri Matisse, who captured the flowing rhythms in his painting *La Danse* (1910). Kerr enjoyed this communal dancing, but what she preferred was to stand back and watch, and then afterwards make drawings and paintings of it from memory. Her own physical experience of dancing is evident in her pictures, which so ingeniously show children from every angle as they move round the ring. There is such a wealth of grace, energy and innocence in these drawings, including a beautifully observed moment when one little dancer almost swerves off course, but keeps going.

And Kerr kept going with her drawing: one might expect to find traces in her early work of the trauma and the political uncertainty that prevailed at that time, but she never alluded to scary things. They were not consciously filtered out, but she really only drew what she had seen for herself and stored in her memory. That said, she does remember an ambitious plan she had to make a composite drawing of 'Scenes of Horror from the First World War'. But she gave up, it was so difficult to draw a man lying face down in a trench, impossible to get the position right, and she could not cope with the gun. However, looking at some of her concise childhood line drawings of things like bicycles, motor vehicles and architectural details, it is clear that she was seldom defeated by complexity and always ready to confront – if not conquer – such things as perspective and foreshortening. What makes her drawings from this period

OPPOSITE, ABOVE
Pencil and watercolour drawing of a Belgian beach, 1935

OPPOSITE, BELOW
Pencil and watercolour drawing of a festive scene, *c.* 1933

OVERLEAF
Pencil and watercolour drawing of children circle dancing in Switzerland, *c.* mid-1930s

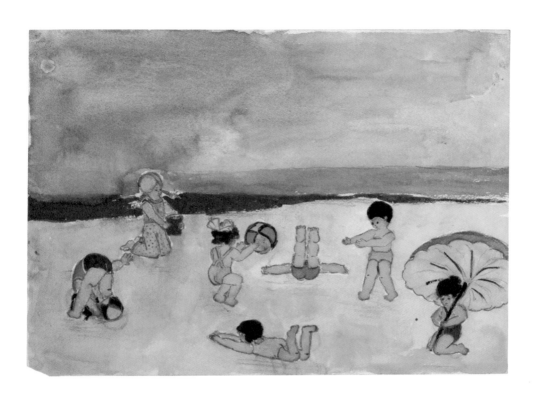

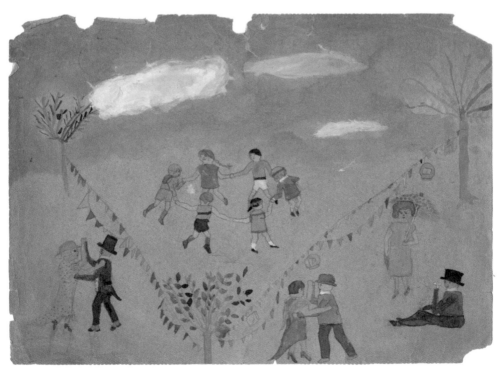

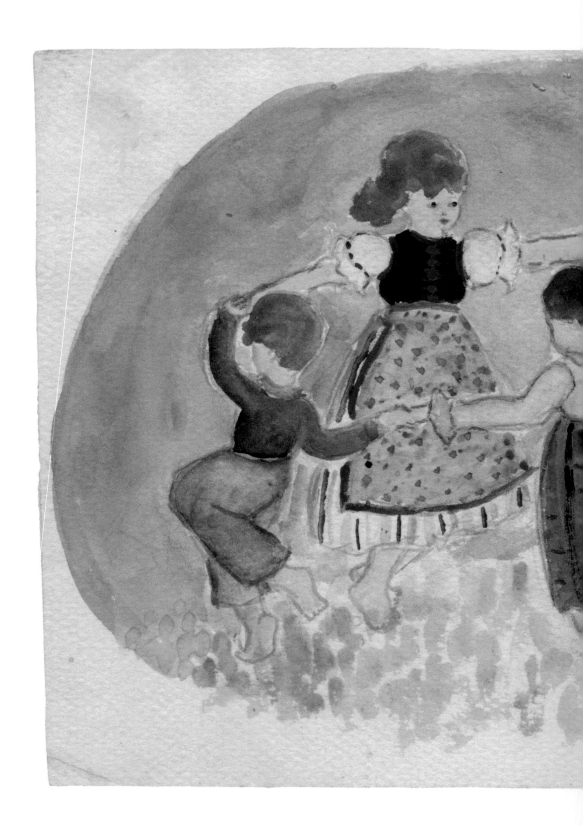

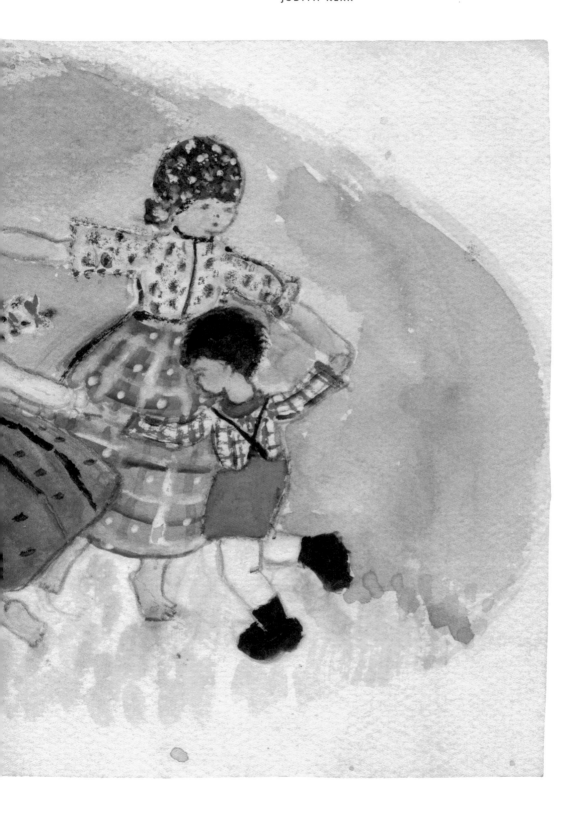

so irresistible though is the abundance of narrative detail she includes. In a lively drawing of children playing after school, you can see in the background a man who, having tossed a coin for a street musician, walks away, clearly rather impressed by his own generosity. It is the way he holds his head – a small miracle of body language.

Another school scene presents a very different, rather oppressive atmosphere. This was in Switzerland. A maths lesson is going on. A dull sky, seen through heavily framed windows, offers no promise of life after school. The teacher's desk, sternly drawn in perfect perspective, stands as a rigid symbol of authority. But then, away to one side, a little girl sits all alone on a hard wooden chair, weeping. Again, there is a strong sense of storytelling, and one cannot help wondering what is going on. Kerr's latent talent for illustration is obvious here, though even at that age she planned to be a painter.

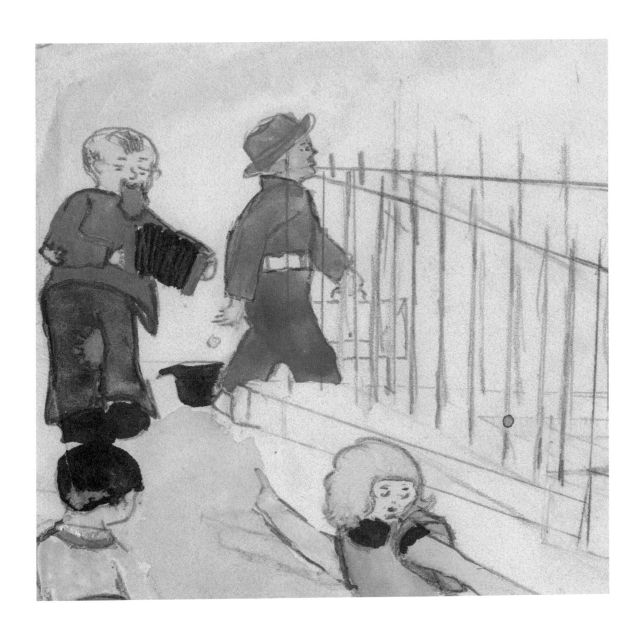

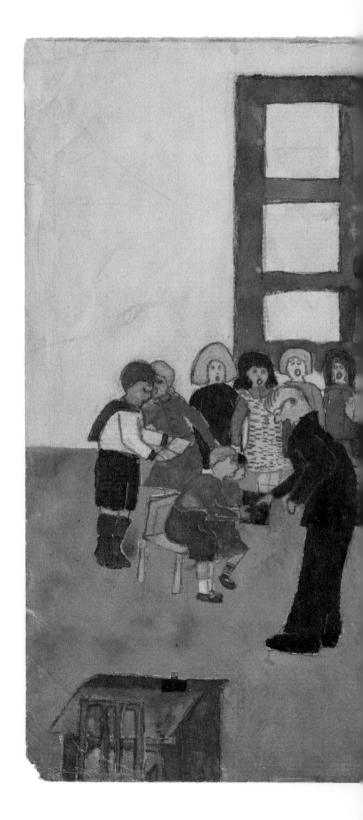

Drawing in pencil and watercolour
of a schoolroom in Switzerland,
c. 1933. Here all the children are
happily occupied except for the
child who sits alone, weeping

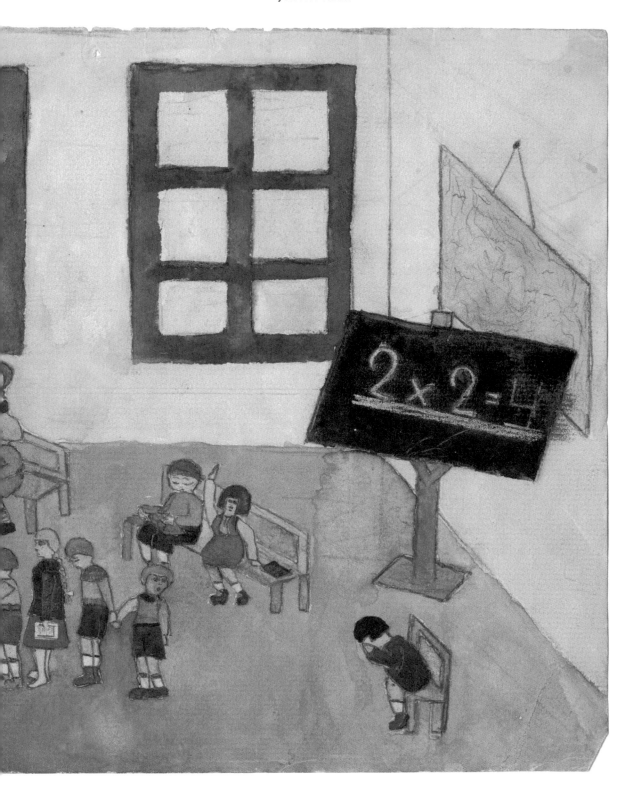

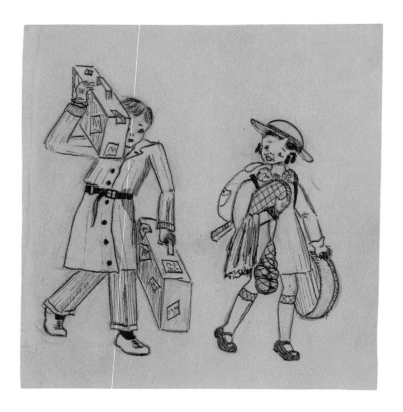

A new life in London

Kerr's ability to adapt to new circumstances was put to the test once more in the autumn of 1935 when she and her brother went to Nice to stay in the well-ordered household of their maternal grandparents while their parents tried to establish themselves in England. Finally, in March 1936, Alfred and Julia collected their children and took them to London. Alfred, trying a new genre in a determined effort to earn money, had written a screenplay about Napoleon's mother. Unable to sell it in France, he sent the script to the eminent film producer Alexander Korda, founder of London Films, who acquired it for a life-saving £1,000. The film was never made but the money enabled the family to begin a new life in the relative security of the British capital, and they settled in rooms in a shabby hotel in Bloomsbury. The children got to grips with another language and their education was attended to: Michael, an academically

ABOVE

Drawing of Michael and Judith, *c.* 1935. The original caption, in German, 'We're going on a journey', reflects the siblings' refugee life of packing up and moving on

OPPOSITE, ABOVE AND BELOW

Drawings of Michael and Judith's stay with their maternal grandparents in Nice, 1935–36. The top image has the caption, in German, 'Quick, a gherkin!!!', referring to a remedy for spilt red wine. The original caption, in German, to the image below was: 'Your silly granddad has locked me in again!'

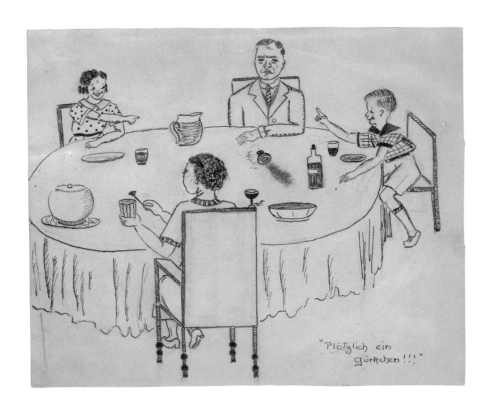

"Plötzlich ein
gürkchen!!!"

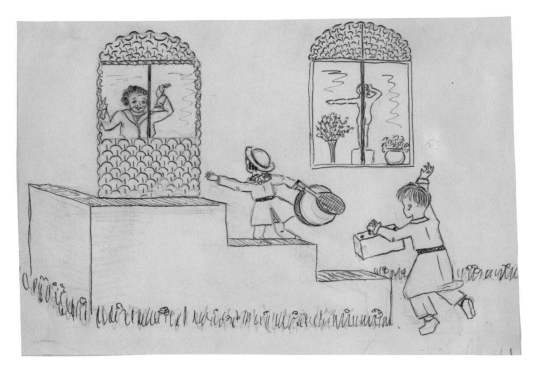

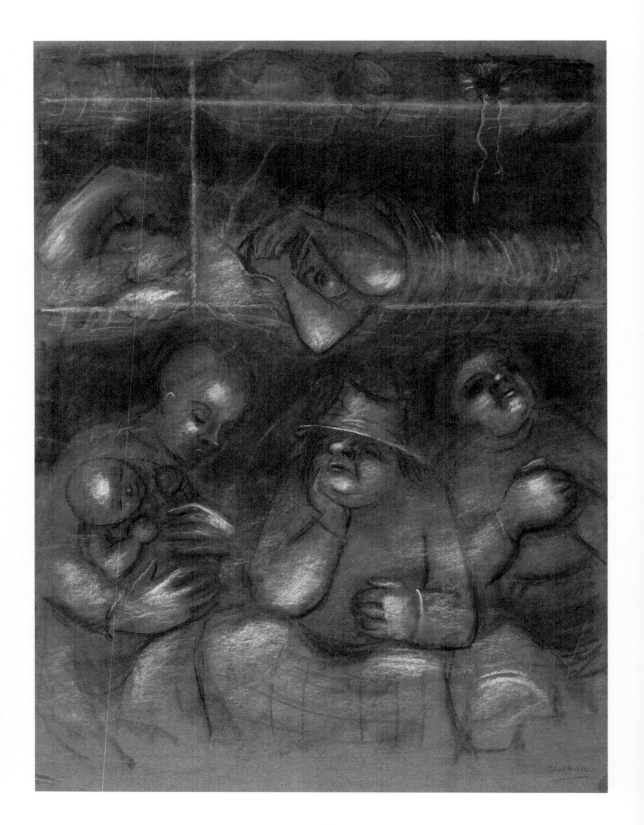

outstanding pupil and a brilliant footballer, was sent to Aldenham School in Hertfordshire, where he was awarded scholarships when the family was unable to continue paying the fees, and he went on to have a distinguished legal career, becoming a Lord Justice of Appeal. In 1938, Judith, with the help of benefactors, enrolled at the 'rather snobbish' Hayes Court boarding school, which she endured long enough to pass her School Certificate at 16 just before war broke out in September 1939. She then started a foundation art course at the London Polytechnic at the beginning of 1940 but again money problems intervened and after a term she was obliged to stop. Her mother had found secretarial work but her father, despite concerted efforts and appeals to friends and contacts, including Albert Einstein, had no outlet for his considerable talents, although he kept on writing.

With the fall of France and England threatened with invasion, the war began in earnest. In *Bombs on Aunt Dainty* (1975), Kerr's second book in the *Out of the Hitler Time* trilogy, she wrote about life in Bloomsbury with a collection of similarly displaced persons, many of them refugees from countries overrun by Hitler's armies in the spring of 1940. They had stories to tell about bombs and air raids. Even from the time of the Spanish Civil War Kerr had wondered what it would be like living under such conditions. Then, with the Blitz, she began to find out. She remembers having to drag her mattress to the cellar each night when walls were shaking, windows breaking, and somewhere, not far away, bombs falling. Kerr did not think she would live much longer, but deep down she had, and still has, a buoyant spirit that never gives way to self-pity. It was at this testing time that Kerr believes she 'became a Brit'. The tolerance displayed towards her family – officially 'Friendly Enemy Aliens' – and the humour and fortitude with which the population withstood the German onslaught impressed her deeply.

Life improved somewhat when the family was bombed out in October 1940 and moved to Putney, which was less of a target. At about the same time Kerr found a secretarial job with a clothing charity that provided wool to volunteers who knitted scarves, balaclavas and other items for the forces, and passed on the kit of deceased officers for re-use

OPPOSITE
Drawing of Londoners sheltering from bombs during the Blitz

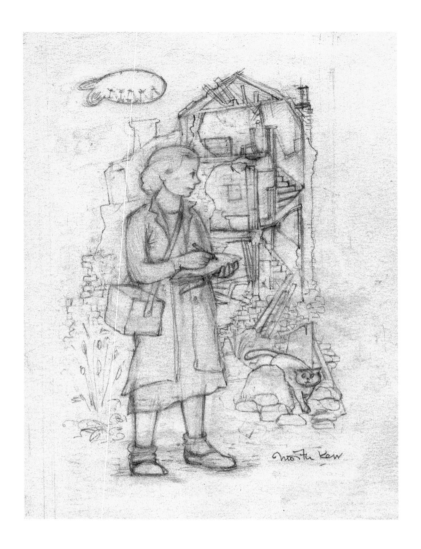

(officers had to buy their own uniforms). In her writing, Kerr moves with seamless sensitivity from one mood to another. In *Bombs on Aunt Dainty* she describes a scene where the charity's staff is dealing with a suitcase full of RAF clothing, donated by the grieving family of a young airman. As the garments are unpacked, a ping-pong ball escapes from a pocket and ricochets around the room. Somehow one can feel that young man's life being played out with every click and bounce of the celluloid ball until – finally – it stops.

It is a heart-rending passage, difficult to forget, and it is followed by an incident in the sewing room, where local ladies came to make hospital pyjamas and bandages.

When news comes through in February 1942 that Singapore has fallen to the Japanese it provokes one of the women to regale the whole sewing party with an endless stream of Japanese atrocity stories, causing such distress that one member of the group suddenly downs tools and goes home 'in the middle of a pyjama jacket', ostensibly to make sure her budgie is safe.

With bombs, blackouts, budgies, bandages, balaclavas, the London Kerr describes is a surreal place, especially if one includes the barrage balloon she saw – and drew – in Vincent Square and a broken bedstead strategically placed in Russell Square to deter enemy parachutists. Throughout the war Kerr was drawing constantly, on buses, trains, in cafés, bombsites and shelters.

Art school

Having long since left behind the world of children's drawings, Kerr's work had entered a new phase. Drawing had always come quite easily to her, but now the more she drew and the more her work improved, she began, paradoxically, to feel out of her depth. She knew instinctively that she had

RIGHT
Drawing, 1940s

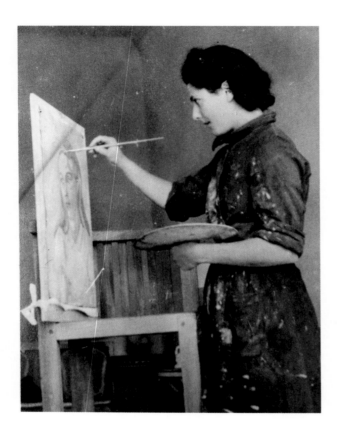

to understand the process more fully; and in 1941, when the art schools opened again for evening classes, she signed up for one in life drawing at St Martin's School of Art. After years of avoiding drawing from life, she now realized that it was a fundamental skill that she needed to master.

The danger of night-time air raids meant that the classes actually took place on Sundays, and life drawing became a regular, eagerly anticipated part of Kerr's life. Even now she talks about it with a quiet intensity, grateful for the fact that it was seen as an essential discipline when she was a young student, and she is sad that it is no longer obligatory in art schools. 'How else can you begin to understand structure and movement in the human body? With regular life drawing you begin to assimilate all that knowledge,' she says, adding confidently that she still has that knowledge safely stored in her head.

Then, with the worst of the Blitz over, she moved on to evening classes at the Central School of Arts and Crafts.

ABOVE
Kerr at the easel in a painting class, late 1940s

OPPOSITE
Life drawing, 1940s

Her most inspiring teacher was the artist and engraver
John Farleigh, known at that time for his strikingly sensual
illustrations for George Bernard Shaw's curious fable *The
Adventures of the Black Girl in her Search for God* (1932).
He instilled in her something of his own passion for drawing
from life, and rigorous investigation of structure. Farleigh
had spotted the talent of the small, attractive dark-haired
girl in his class and thought – as did she – that she should
become a full-time student once the war ended. For that
she would need a scholarship, but because she was not
British born she was not eligible for one. However, on the
strength and diversity of her portfolio (all that non-stop
drawing), and some crafty administrative circumnavigation
on the part of Farleigh and others, she was awarded a trade
scholarship that enabled her to study three days a week at
art school. Farleigh suggested the illustration course but
Kerr, set on pursuing fine art, signed on for the illustration
classes but chose to spend the day in the life-room or
painting instead. Nobody seemed to mind. And she found

OPPOSITE, ABOVE AND RIGHT
Drawings, 1940s

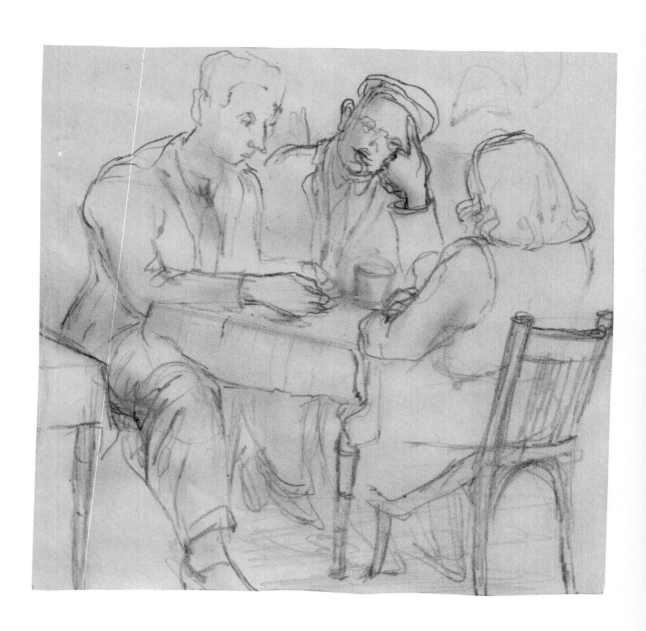

ABOVE AND OPPOSITE
Drawings, 1940s

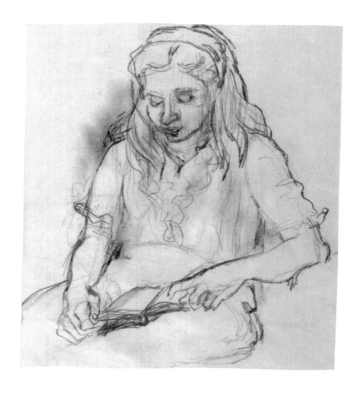

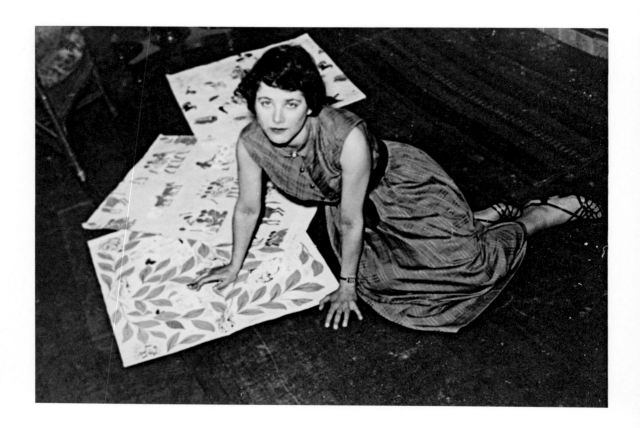

a part-time job in a textile studio. It seems that – aside from her antipathy towards illustration – she was always ready to adapt to new disciplines, new mediums and techniques (it was as a freelance textile designer that she first had the experience of earning money from her art). She created a number of lively designs, but although it was interesting work, painting remained her main focus.

With first-rate teachers and good friends, who included Peggy Fortnum, the original *Paddington Bear* illustrator, Kerr had three happy, hard-working years at Central, painting and drawing from life. But then came the moment of truth when her work had to be assessed for her illustration diploma. She had not known this was coming and because she had not been following the course, and despite some last-minute attempts at illustrating, she failed. She was completely devastated. This was followed later in 1948 by real tragedy: the death of her beloved father. He took his own life, after suffering a stroke on a visit to Hamburg.

ABOVE
Kerr with some of her textile designs, *c.* 1948

OPPOSITE
Jeux d'enfants textile design, *c.* 1948

OVERLEAF
Spring textile design, *c.* 1948

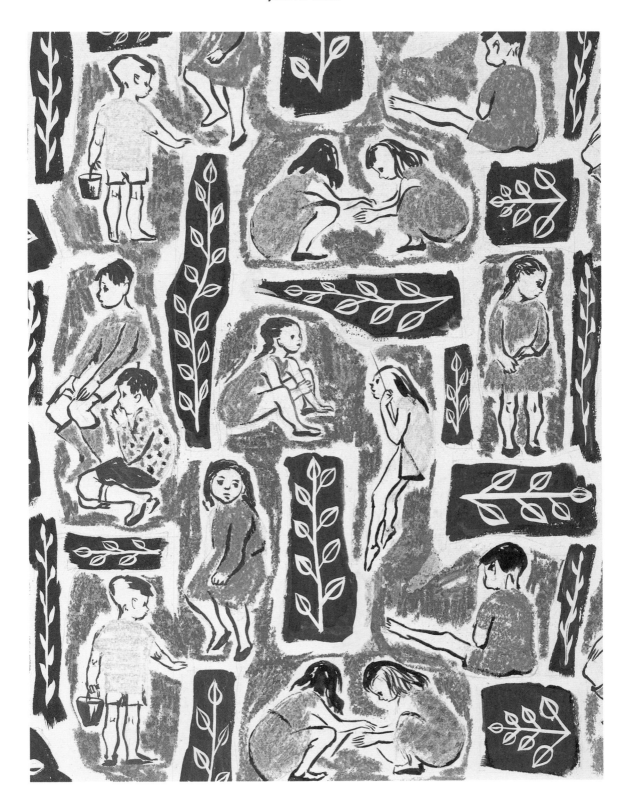

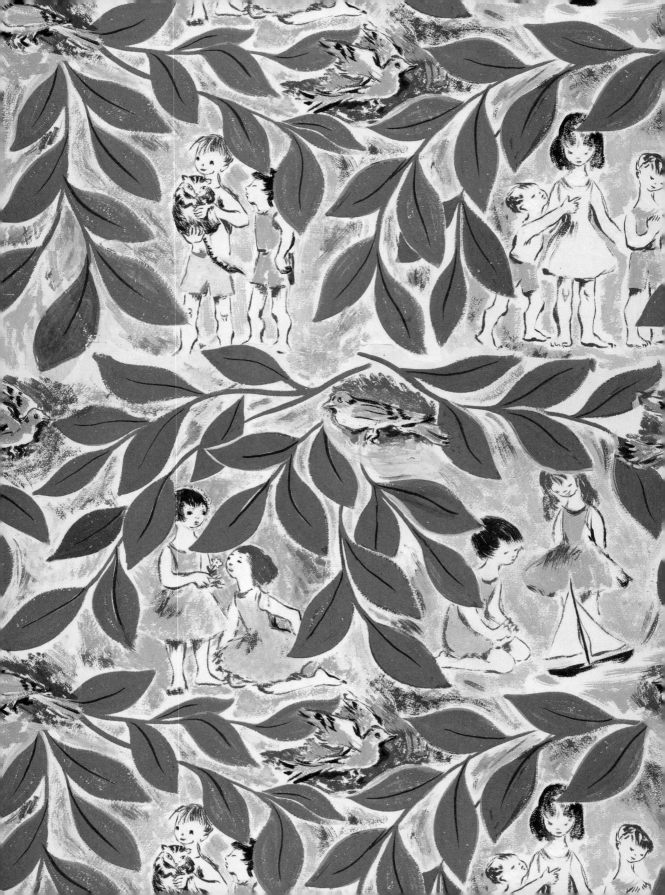

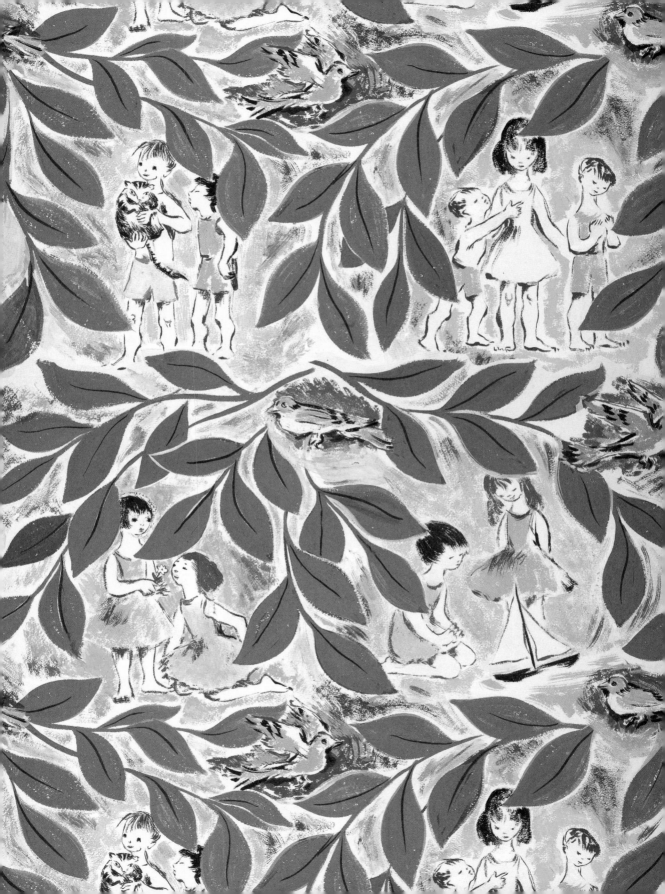

Design for a scarf with London
scenes, *c.* 1948

ABOVE AND RIGHT

Late attempts at illustration
at Central School of Arts and
Crafts, *c.* 1948

Making a living

Kerr had to reorganize and reassess her life, and reflected on the positive aspects of her situation, which was not too difficult: in her last year at Central she won a painting prize; had a picture accepted by the Royal Academy for the Summer Exhibition; and her painting *Three Old Women* was shown with the prestigious London Group and favourably reviewed alongside the work of Graham Sutherland, Kenneth Martin, Ruskin Spear and Julian Trevelyan. She got a job teaching art one day a week at a girl's school in Eastbourne and the train journey from London offered ample opportunities for drawing. One of these sketchbook images – a loosely drawn study of two babies asleep in their parents' arms – inspired her to work further on it. It is an interesting diagonal composition with emphasis on the way the grown-ups' hands are clasped round the infants. She squared it up, and it became an oil painting, which won first

BELOW
Three Old Women, 1948. The oil painting was shown with the London Group

OPPOSITE, ABOVE
Kerr's squared-up composition for the painting that won first prize in the Daily Mail Young Artists Exhibition, 1949

OPPOSITE, BELOW
Kerr receiving her prize from Lady Rothermere in front of her winning painting, Daily Mail Young Artists Exhibition, 1949

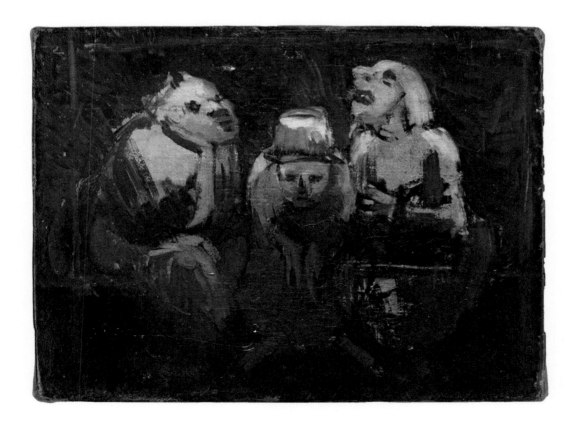

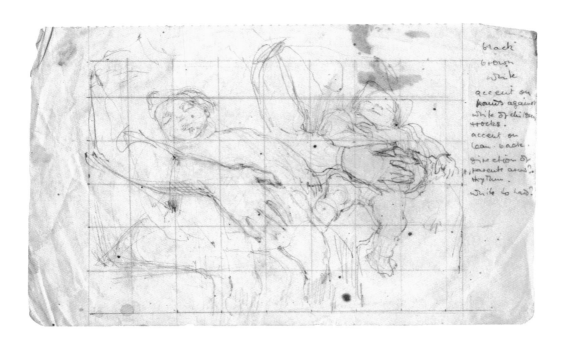

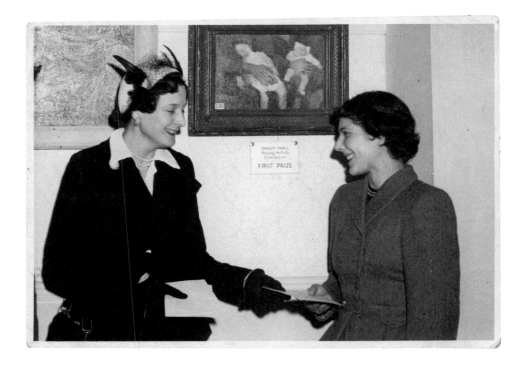

prize in the Daily Mail Young Artists Exhibition in 1949. The £100 award financed a trip to France and Spain, and more drawing.

Optimistic, versatile and hardworking, Kerr never shied away from new experiences. When attending wartime evening classes at Central, she decided to try her hand at murals, not the obvious choice in London at that point: suitable walls being in short supply, thanks to German bombs. Undaunted, she persuaded a café owner in Victoria Street to let her transform his premises. That earned her the princely sum of £15, and led to commissions postwar to paint murals for the nurseries of friends' children, which along with various teaching jobs (including at Eastbourne), kept her afloat financially. Then in 1952 everything changed.

BELOW
Sketch for nursery mural decoration on two walls, *c.* 1950

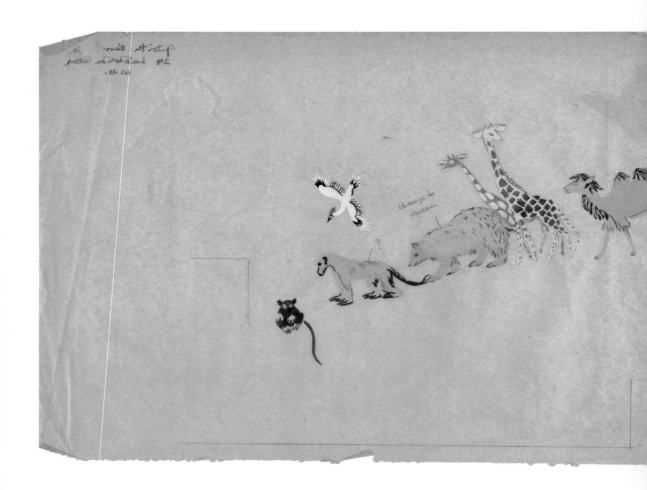

Kerr was teaching art at a girls' technical school in Shepherd's Bush when a friend took her to lunch at the BBC television studios across the road in Lime Grove. There, in the busy canteen, she met Tom Kneale. Originally from the Isle of Man, he had been studying at RADA while she was at Central. As an actor, he had done his share of spear carrying at Stratford, but was already an award-winning author of short stories, and was now working as a scriptwriter at the BBC (his professional name was Nigel Kneale). Their friendship blossomed and Kneale encouraged Kerr to apply for a job at the BBC as a reader of unsolicited plays. Her language skills were useful, as was her ability to write.

Television was a burgeoning medium, boosted by the popularity of the Coronation broadcast in June 1953. That

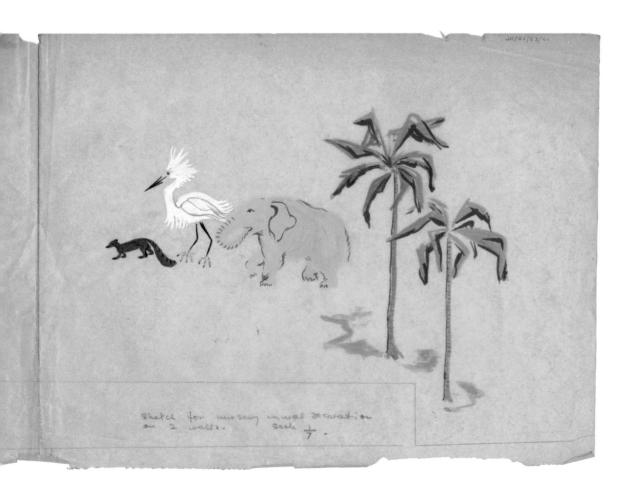

Sketch for nursery mural decoration
on 2 walls. Scale 1/7.

summer Kneale wrote the landmark science-fiction serial *The Quatermass Experiment*, and with their careers more established, the couple married in 1954. Kerr rose through the ranks to become a scriptwriter and wrote a successful adaptation of John Buchan's novel *Huntingtower* (1922) in 1957. She and Kneale were happy working together in television at a time when, as she says, it was probably 'more exciting than either before or since'. However, life changed again with the birth of the couple's daughter, Tacy, in 1958, and their son, Matthew, in 1960. Kerr left the BBC and Kneale went freelance, going on to write the script for the film *The Entertainer* (1960), starring Laurence Olivier, among other high-profile projects.

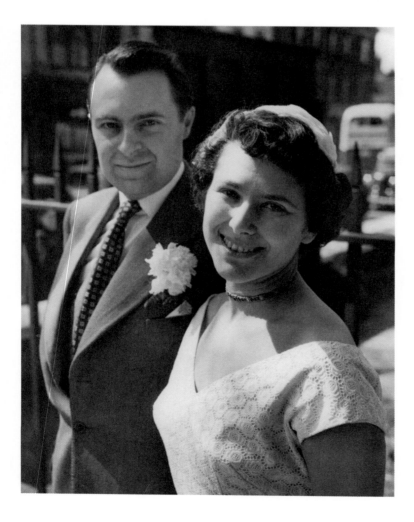

LEFT
Judith Kerr and Tom Kneale on their wedding day, May 1954

The Tiger Who Came to Tea

It was not until the children were at school all day that Kerr began to think about getting back to work. Reluctant to return to the BBC and having set aside painting for the time being, she decided to try making a picture book for young children – not because she had had a sudden desire to be an illustrator after all, but largely because she had difficulty finding good books for her own children. But things were rapidly changing: it was now the 1960s, a revolutionary era in children's publishing, with exciting developments in colour reproduction and an abundance of new talent. Kerr was inspired by the work of Brian Wildsmith and many others, but it was John Burningham in particular who really 'got her going' as an illustrator, with his book *Humbert* (1965).

The story for her first book came easily: she had been taking Tacy to the London Zoo, and it was the child's unusual fascination with the tiger that gave her the idea. And in those long afternoons at home, time would hang

RIGHT
Sketch of Tacy and Matthew,
c. 1966

OVERLEAF, LEFT AND RIGHT
Zoo sketches, *c.* 1967

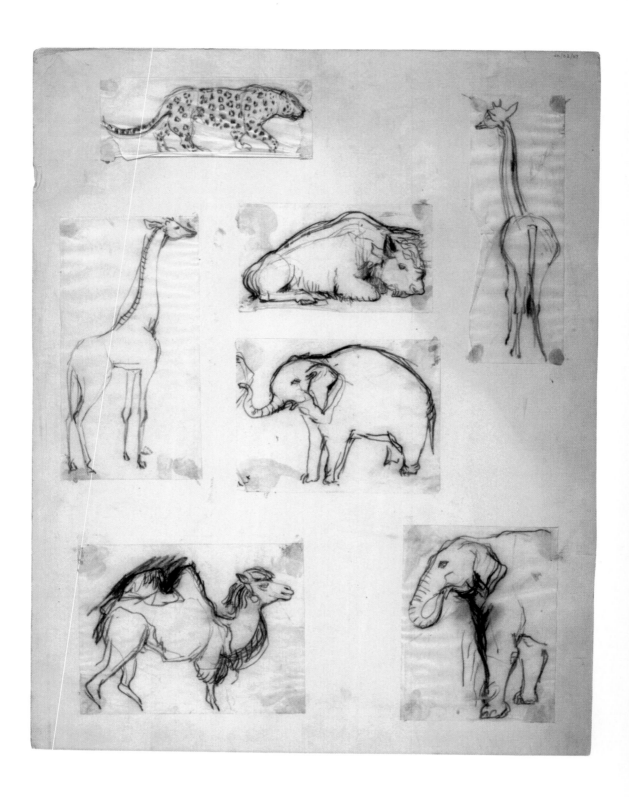

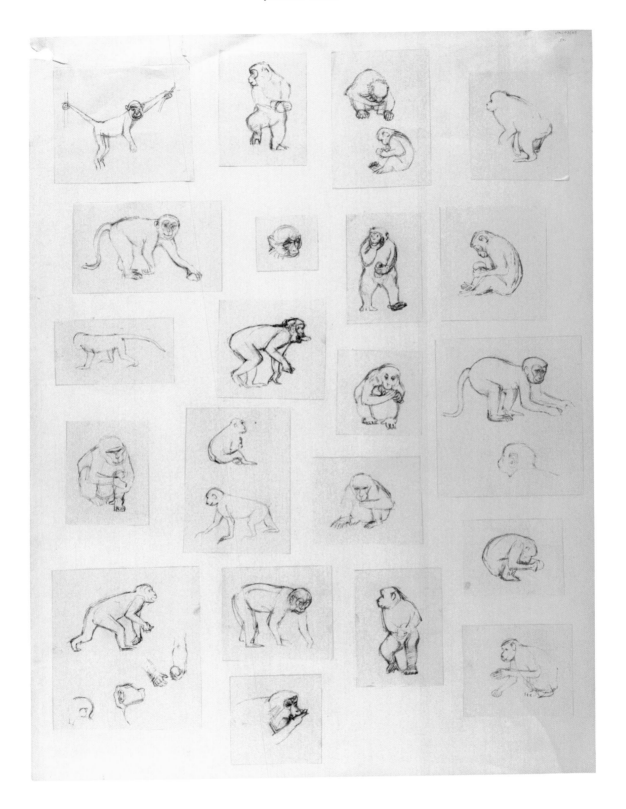

heavy and by teatime mother and daughter would be longing for something to happen. 'Talk the Tiger', Tacy would command. She was spellbound. A nameless tiger arrives at the house, though nobody knows where he has come from. Nor do they know where he is going when, having eaten an enormous tea consisting of iced buns, cakes and biscuits, he slips away discreetly, leaving not only a good deal of clearing up, but also a tantalizing whiff of magical realism, though that was not a term used at the time the book came out in 1968.

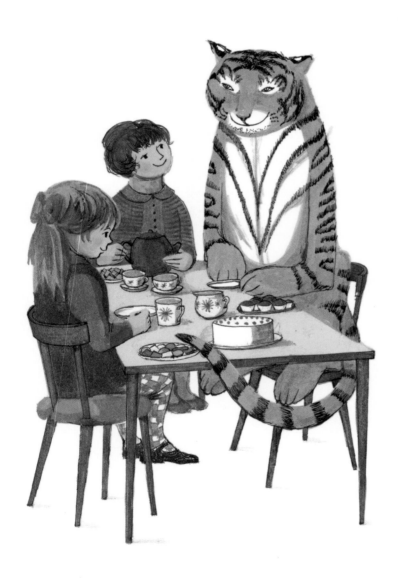

LEFT AND OPPOSITE
Illustrations from *The Tiger Who Came to Tea*, 1968

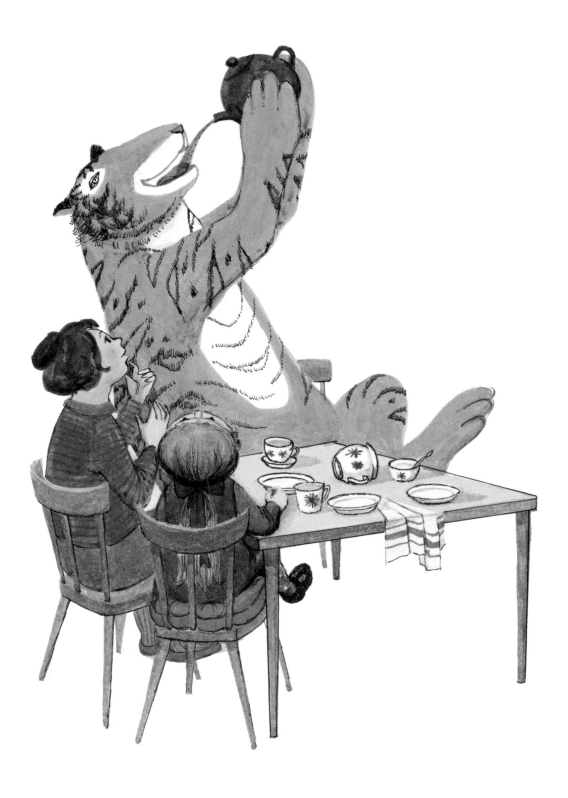

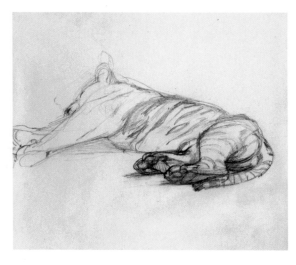

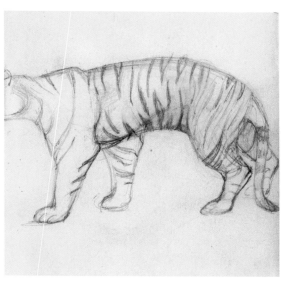

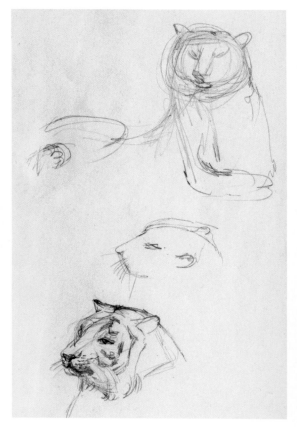

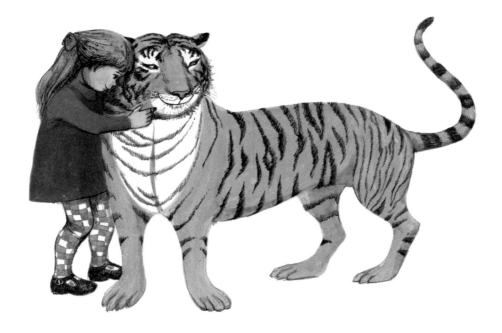

OPPOSITE
Zoo sketches, *c.* 1967

ABOVE
Illustration from *The Tiger Who Came to Tea*, 1968

Told and retold every night at bedtime, the tiger story grew and grew, with Tacy constantly demanding new episodes, and the story itself demanding illustrations. It clearly had to become a picture book, but Kerr, although an accomplished artist, had no experience of illustrating a story and she had not done any serious drawing for about twelve years. There were more trips to the Zoo, and more and more drawings. However, when she finally embarked on the illustrations, she found she could not handle the watercolours she had been planning to use.

It was the idea of a friend from art school days, Brian Davis (the cartoonist Michael Ffolkes), that she should try using waterproof coloured inks. Indelible, slightly viscous and very brush-friendly, they came in a range of glorious colours. Having chosen some tigerish hues, she tried them out and soon discovered that by building up the colours little by little, layer upon layer, they developed an incomparable richness, ultimately achieving that 'lit from within'

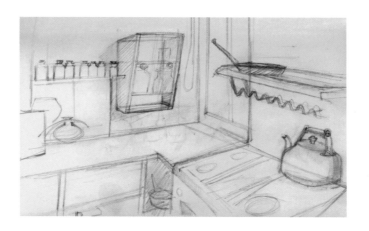

OPPOSITE AND RIGHT

Drawings of Kerr's kitchen that provided source material for *The Tiger Who Came to Tea*, 1968

luminosity that to this day distinguishes and defines the enigmatic tiger, who has become such a celebrity.

When it came to putting the book together, Kerr had a difficult time. With no overall plan, and having missed all those illustration lectures, she knew nothing about such things as layout and page design. She tried to do it by looking at other picture books in the shops, but it was no good and pictures and text got squashed together. Nonetheless, she had to start somewhere, so, as she puts it, she just closed her eyes and jumped in.

Using the many naturalistic sketches she had done at the Zoo, Kerr's tiger emerged as a well-constructed creature, by turns enigmatic, flamboyant, smiling and somnolent. Drawing a tiger at the Zoo was not unlike drawing a model in the studio; in both cases she was carefully exploring the structure of the beast. The difference was that in the book she had to deal with the tiger's massive presence alongside that of a small girl. But she magically adjusted the sense of scale in such a way that child and tiger are on an equal footing, and have a natural respect for one another.

Kerr was uncertain as to whether the tiger should be wearing clothes – or a top hat perhaps – or to depict him as he would be in the wild. This was soon resolved. Among the early pencil drawings is one of him in the kitchen, crouched hungrily on top of the fridge, like a tiger in the bush stalking its prey. However, in the finished artwork he is no longer a predatory beast, but simply a free spirit with an engaging, if slightly distant manner. Drawn with a combination of graphite pencil, coloured inks and coloured pencil, he cuts a handsome figure, strikingly orange against the plain lines of the very 1960s fitted kitchen, the backdrop of the whole story, for which Kerr made countless preparatory drawings. She recalls that she found the scene where the tiger is lying next to the sink drinking from the tap difficult, but that she 'soon got a feel for it – and then, about two thirds of the way through, I found I had a really clear idea about how to do it'.

Tacy, with her engaging profile, her all-seeing gaze, and her confident stance, was the model for the little girl, Sophie. Kerr captures the child observing with wonder and disbelief the tiger's outrageous appetite and enthusiastic exploration of the food cupboard but also her affection for the unusual

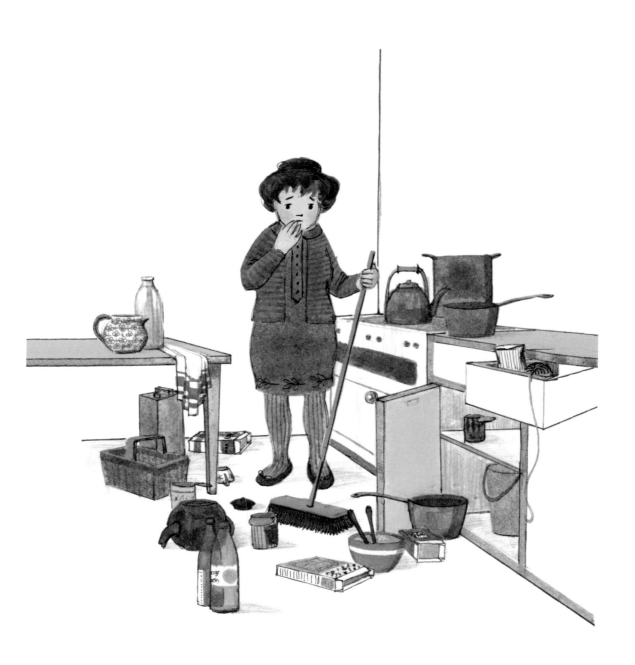

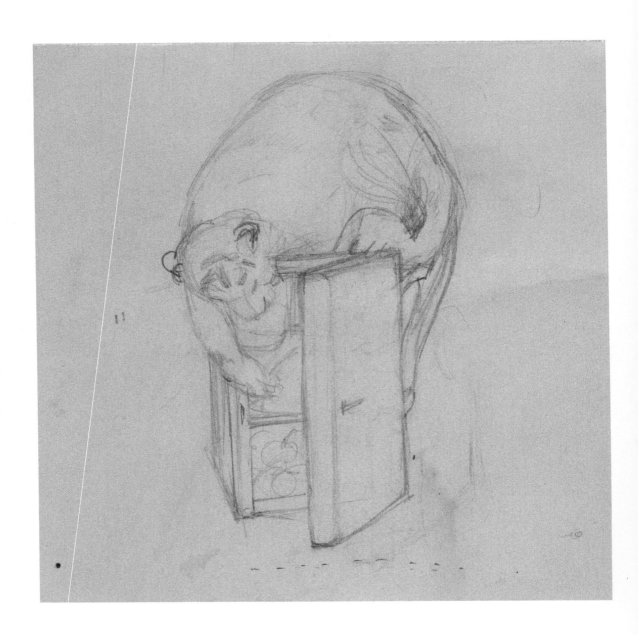

ABOVE

Preliminary drawing for *The Tiger
Who Came to Tea*, 1968

OPPOSITE

Illustration from *The Tiger Who
Came to Tea*, 1968

64

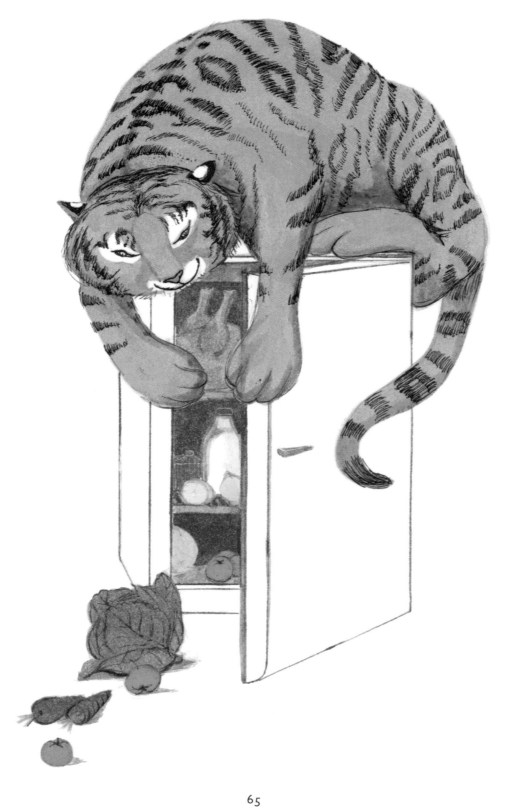

visitor. Kerr and Tacy had always had a close relationship and easy understanding of one another, and as she worked, Kerr was helped immeasurably by knowing exactly the sort of things her daughter would like to see in the pictures: what would be familiar to her, what would surprise her and what would make her laugh.

As a middle-aged first-time author, Kerr had some misgivings when she first showed the book to her husband's literary agents, after nearly a year's work. They were enthusiastic enough to take it to Collins (now HarperCollins) where the children's book editors liked it, even if they had curiously unimaginative reservations about the tiger drinking *all* the water in the tap. But Kerr insisted that this was the part her children liked best. They also had some discussion about the title. Kerr had called the book *Tacy and the Tiger*, but it was felt the name Tacy was too unusual. Hence Sophie was born and the book became simply *The Tiger Who Came to Tea*. However, it was the art director, Patsy Cohen, to whom Kerr feels she owes the most. It was Cohen who taught her not only how to plan and storyboard a book but also everything else she would have learnt had she attended the illustration classes at Central. It was to be the beginning of Kerr's long association with Collins.

The Tiger Who Came to Tea was an instant success and has now been in print for over fifty years, translated into twenty languages and with sales in the millions; it has even been adapted for the stage. It has proved to be a beguiling, thought-provoking book although Kerr is reticent about some of the curious interpretations and metaphorical – political or sociological – meanings people have dreamt up for this story. Essentially, she says, it is about a child's astonishment, and unalloyed delight, when something both totally unbelievable and truly wonderful happens right before her eyes.

OPPOSITE

Illustration from *The Tiger Who Came to Tea*, 1968

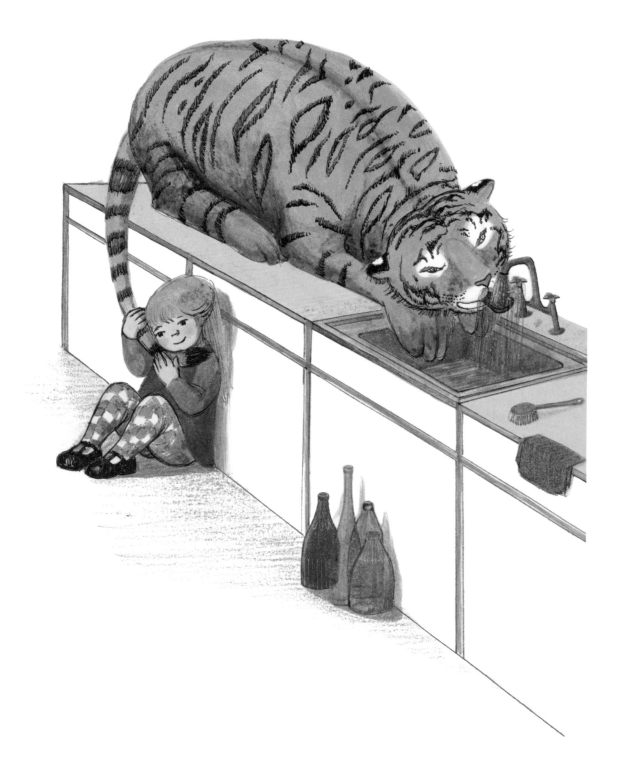

Mog

The *Tiger* book was soon followed by *Mog the Forgetful Cat* (1970), the first of seventeen volumes following the adventures of this creature who is 'nice but not very clever'. After that inscrutable tiger, Mog is quite different: a cat who lives in an unremarkable house with Mr and Mrs Thomas and their two children, leading a conventional family life, the very opposite to that which Kerr herself experienced as a child. It was a poignant reminder that her family's way of life could never have included a pet cat.

Everybody loves Mog, in spite – or maybe because – of the way she so regularly, so accidentally and sometimes so spectacularly, subverts the everyday rhythm of the Thomas's suburban domesticity. Mog, although comfortable in her own skin, is easily frightened out of it; she's prone to getting the wrong end of the stick and to making ill-considered decisions. But, like the tiger, she has become an iconic presence in children's books worldwide – a very fine specimen, sturdy for a cat, but irresistibly tactile – drawn on Bristol board, first

BELOW
Early drawings of Mog

OPPOSITE
Kerr at work on *Mog the Forgetful Cat* with the original Mog on her lap

OVERLEAF, LEFT
The first page of the initial draft of *Mog the Forgetful Cat*, c. 1970

OVERLEAF, RIGHT
The first page of the original flat plan for *Mog the Forgetful Cat*, c. 1970

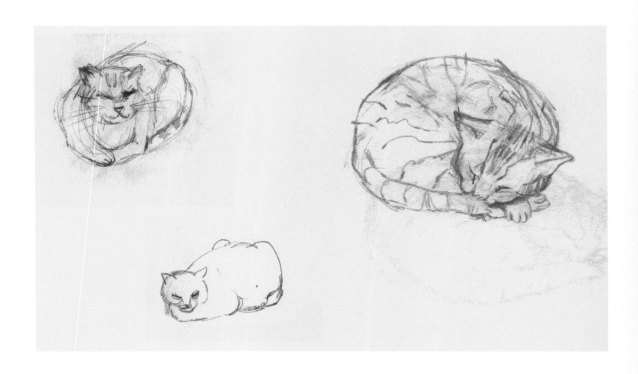

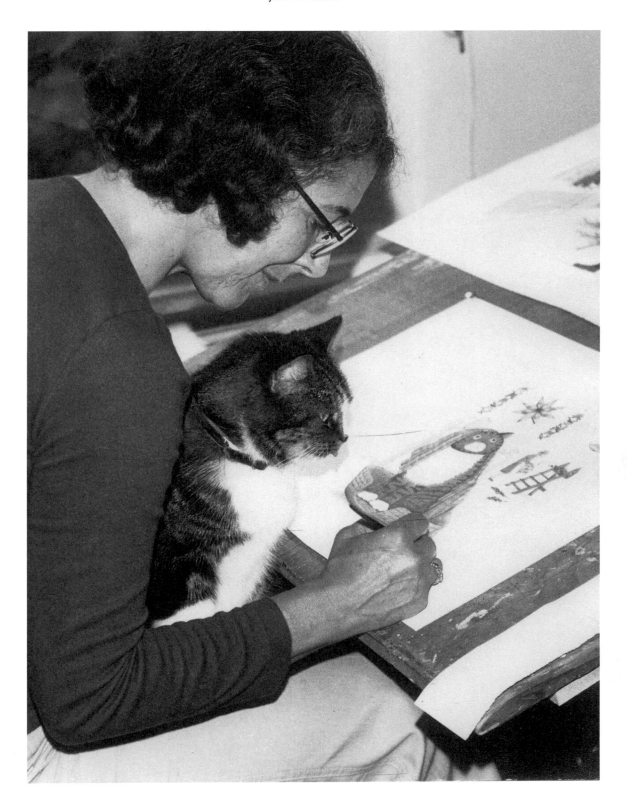

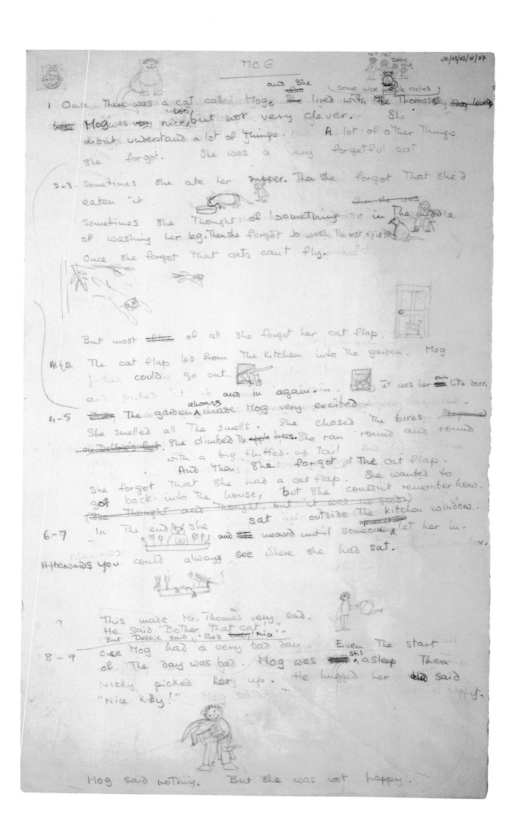

MOG

1. Once There was a cat called Mog. ~~She~~ lived with ~~the~~ Thomas's ~~they loved~~ and she (some nice people called)

~~the~~ Mog was ~~very~~ nice, but not very clever. She too didn't understand a lot of things. A lot of other things she forgot. She was a very forgetful cat.

2-3. Sometimes she ate her supper. Then she forgot That she'd eaten it

Sometimes she thought of something ~~else~~ in The middle of washing her leg. Then she forgot to wash the rest of it. Once she forgot that cats can't fly.

But most ~~often~~ of all she forgot her cat flap.

The cat flap led ~~from~~ The kitchen into the garden. Mog could go out... and pulled it to and in again in. It was her own little door.

4-5. ~~But~~ The garden always made Mog very excited. She smelled all The smells. She chased The birds. She climbed the ~~apple~~ trees. She ran round and round with a big fluffed-up tail. And then she forgot The cat flap. She forgot that she had a cat flap. She wanted to get back into the house, but she couldn't remember how. ~~She thought and thought, but it was no good.~~ sat outside The kitchen window.

6-7. In The end she sat and ~~she~~ meaowed until someone let her in.

Afterwards you could always see where she had sat.

? This made Mr. Thomas very sad. He said "Bother That cat!" But Debbie said, "She's ~~very~~ nice!"

8-9. Once Mog had a very bad day. Even The start of The day was bad. Mog was still asleep. Then Nicky picked her up. He hugged her and said "Nice kitty!" Mog said...

Mog said nothing. But she was not happy.

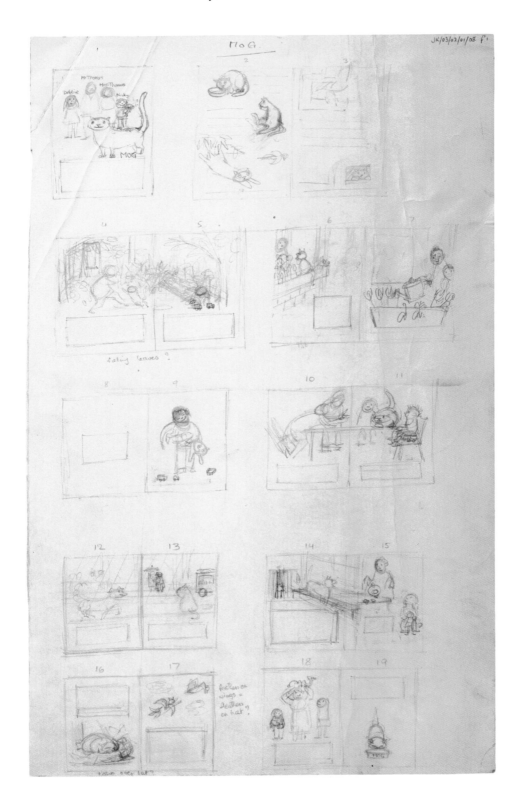

Thomas said "bother that cat

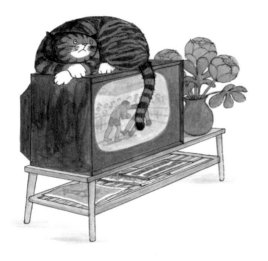

OPPOSITE, ABOVE
Drawing of Mog on the television, from the initial draft of *Mog the Forgetful Cat*, *c.* 1970

OPPOSITE, BELOW
The original flat plan shows the next stage in the development of the scene

ABOVE
Finished illustration from *Mog the Forgetful Cat*, 1970

in pencil, coloured with diluted ink, then worked into with pen and coloured pencil to create volume. And finally, ink for the stripy detail, which is a labour-intensive business, especially on the tail.

Kerr's familiarity with feline physiognomy allows her, in the interest of character, to take affectionate liberties with Mog's appearance. However, she never ridicules her, never overdoes the anthropomorphism and importantly allows her to keep some of her (many) secrets and opinions, although the two children seem to have a direct line to her innermost thoughts. When things go wrong and those innermost thoughts come to the surface, Mog, although she is essentially a bit of a dimwit, has no trouble making her feelings known with an unrivalled repertoire of facial expressions, such as the cross-eyed desperation she exhibits one day when, in *Mog's Bad Thing* (2000), she cannot locate her lavatory and is obliged to relieve herself in Mr Thomas's armchair. As author and illustrator, Kerr has a golden rule

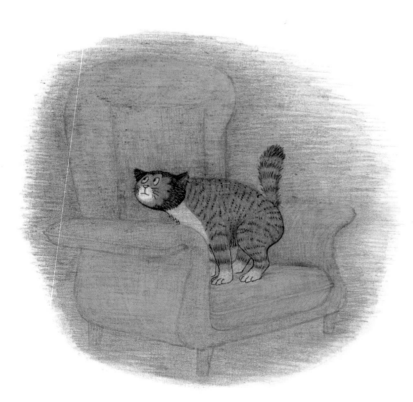

Illustration from *Mog's Bad Thing*, 2000

OPPOSITE
Illustration from *Mog the Forgetful Cat*, 1970

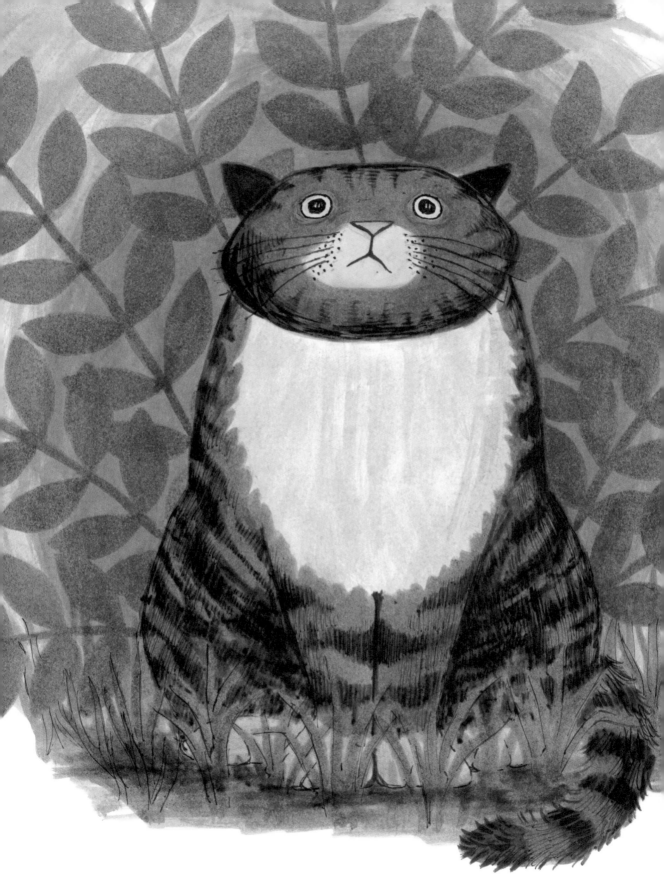

that the text never needs to include anything that is clear from the illustrations (why should children struggle to read something that they already know?), and here she manages to be both explicit and discreet. And when Mog is airborne – as she so frequently is, whether in dreams or reality – her body language is even more eloquent: her inflight ecstasy is easy to imagine, as is the furry thump when she touches down.

Most of the *Mog* stories are built round domestic incidents in a busy household: thrills, spills, misunderstandings, and even a remorseful burglar in the first book. However, in *Mog in the Dark* (1983), Kerr explores a very different territory, using a vocabulary limited to just over 50 words (with a nod to *Green Eggs and Ham* by Dr Seuss, whom she also emulated in keeping to a vocabulary of about 250 words in the other *Mog* books), and artwork that makes evocative use of colour as Mog sits outside in the garden, on a dustbin, still and silent, in pensive mood, thinking dark thoughts. It is evening. The noisy colours of daytime are transformed under a dusky veil of twilight, and in the flowerbed, among scumbled shades of green, there are dusty pink roses, heavy with sleep, nodding off after a hot day. Mog, too, is drifting off and soon, high on catnip perhaps, she is up and away on a hallucinatory journey flying like a bird in a wonderful aerobatic display before touching down – or crash landing – in a tree in her own garden.

Twenty-five years later, in *Goodbye Mog* (2002), she touches down for the last time. She dies peacefully in her sleep, her spirit rising from the cat basket in a gentle gauzy mist. This glorious transmogrification scene is absurdly moving, Mog's expression is so believable, sad but uplifting, and she is confident in the knowledge that even from the Great Beyond her spirit will always be ready to help when a new kitten is inevitably introduced into the family. This totally unsentimental, perfectly judged story achieved a unique status when Philippa Perry, Kerr's steadfast friend and inventive publicist, managed to arrange an obituary for Mog in the *Guardian* newspaper.

Nonetheless, Mog had a final reappearance in 2015 as the star of Sainsbury's Christmas television advertisement.

ABOVE
Illustration for the cover of *Mog's Christmas Calamity*, 2015. This book was a tie-in with the Christmas television advertisement for Sainsbury's supermarket

OPPOSITE AND OVERLEAF
Illustrations from *Mog in the Dark*, 1983

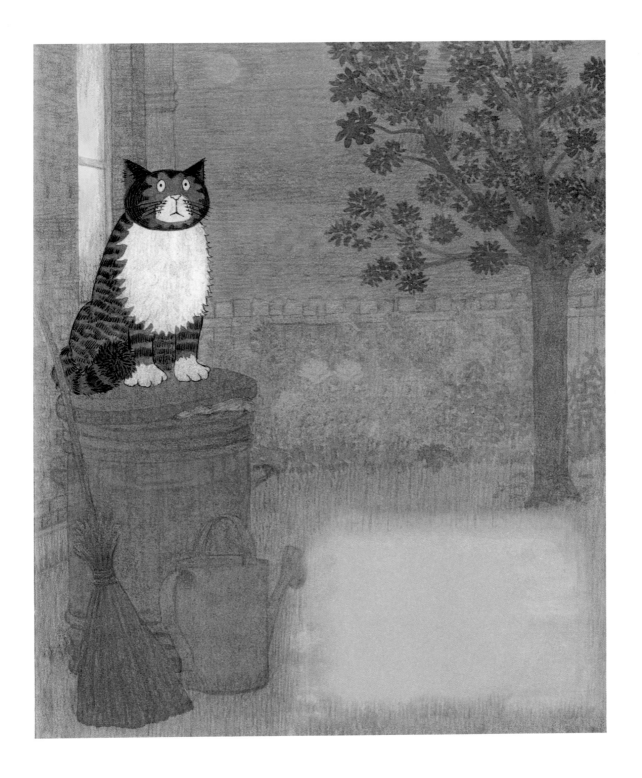

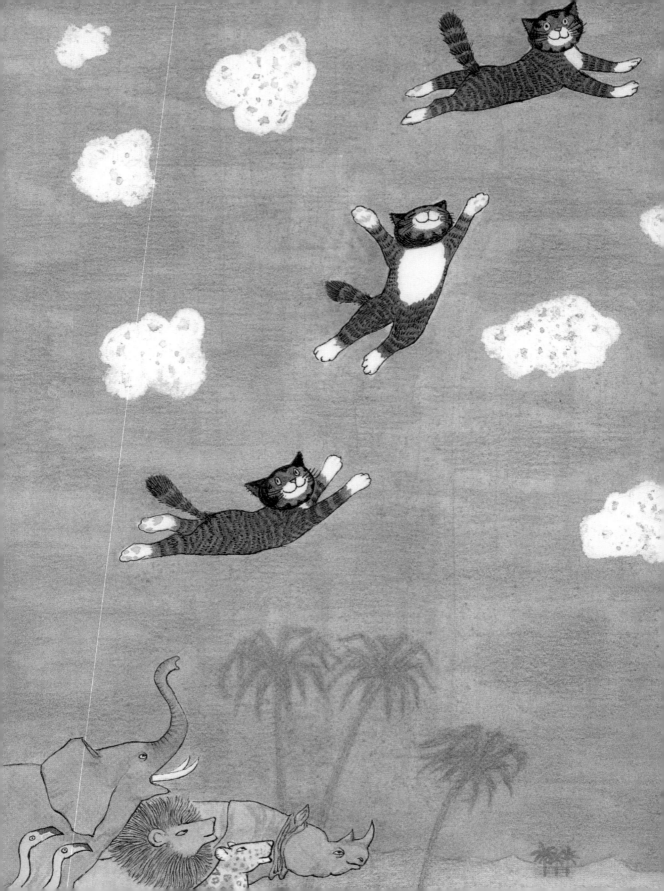

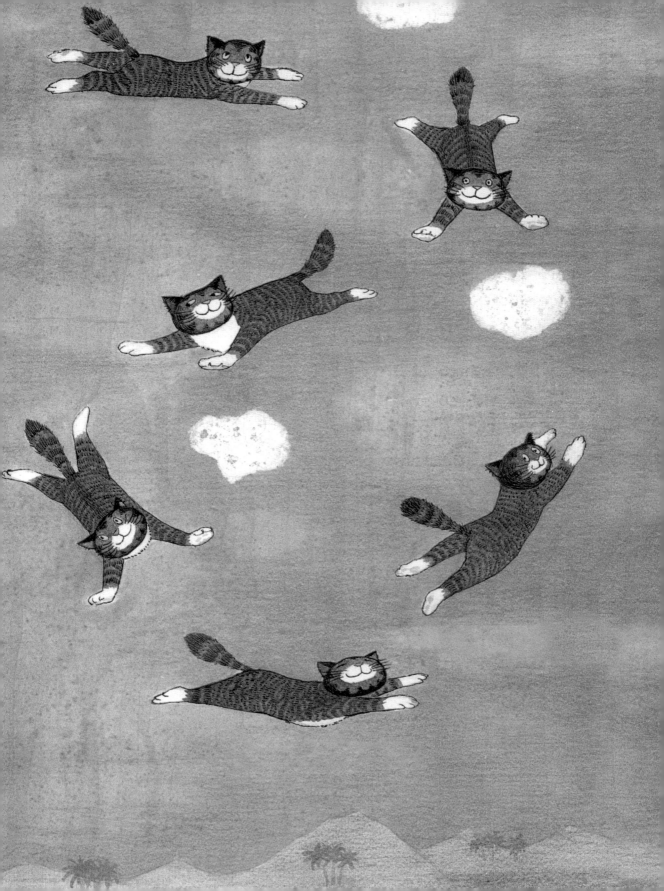

Home and studio

All Kerr's books have been produced in the same Edwardian terraced house in southwest London that she and her husband bought in 1962. At that time it was a slightly rundown area, but there were like-minded neighbours, many of them also working in the arts and the media. Being a large house, there was sufficient space for both artist and author to have a workroom.

The house seems full of books, jostling for space on the many shelves, tabletops, windowsills and ledges. There are family portraits, including one of Kneale by his brother Bryan Kneale, a distinguished sculptor. A delicate, perceptive portrait of Kerr by her daughter hangs in the hallway. Tacy is an artist who trained as an actress and

has subsequently worked in theatre, television and film, at one point creating fabulous creatures for Harry Potter films. There are photographic prints from all over the world by her son, Matthew, an award-winning novelist who has also written a history of Rome, where he lives with his family. The kitchen is familiar as the place where the tiger once made himself at home.

Although Tom died in 2006, with all the paintings, photographs, books, theatrical memorabilia, a huge collection of hats and a fragile rather elderly Quatermass figure that sits by his desk, he is still a presence in a house that so warmly celebrates the diverse talents of this remarkable family. On the top floor of the house are the adjoining rooms where for so many years the couple, writer and artist, used to work together. 'It was such a happy time,' Kerr recalls. 'We would work all day, close to one another, while the children were at school. And we could talk.' Tom was always ready to help her with ideas, plots, titles – 'and oh, he could be so funny'.

Her workroom is painted white to maximize the light and there is a vast plan chest, a light-box and a huge copying machine, which is vital to her work. When she has got a drawing just right – a face, say, or an expression, or a particularly eloquent gesture – she will make a copy, so she can work further on it without fear of losing its original spark. The drawing table is a rather rickety affair at which she has created all her books. There are three lamps on it that jiggle and sway when she is rubbing out (and that is quite often) and there are several spiky bouquets of lethally sharp pencils.

Around the room there is an eclectic collection of art books – Rembrandt is clearly a favourite. And there is a book with an old engraving that is very special to her: it is of her father's father, who as a young man wanted to be an artist but that was not allowed, so she keeps the picture in her workroom 'so he can be part of things here'. There is a model of a Sicilian horse and cart, a radio ('for classical music, but not opera' she says, quite firmly), and on the wall, a very rustic-looking baskety object. 'Oh yes! That's something Matthew brought back from his travels in the East. It's a special pouch for taking baby pigs to market' (and it is not

OPPOSITE

Tom Kneale in his study, *c.* 1976, with the creature from *Quatermass and the Pitt*, 1958–59, the third and final *Quatermass* television serial that he scripted

OVERLEAF

Judith Kerr, 2018, photographed by Zoë Norfolk

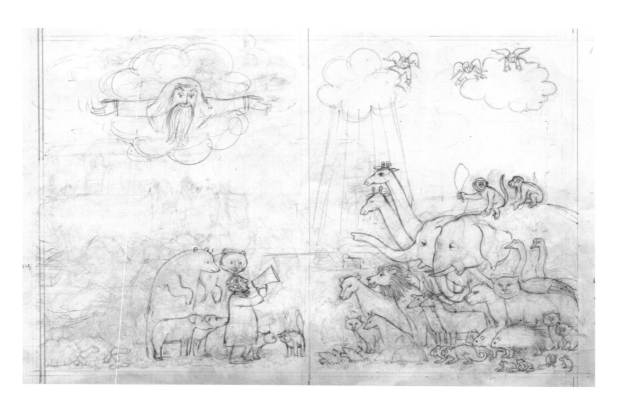

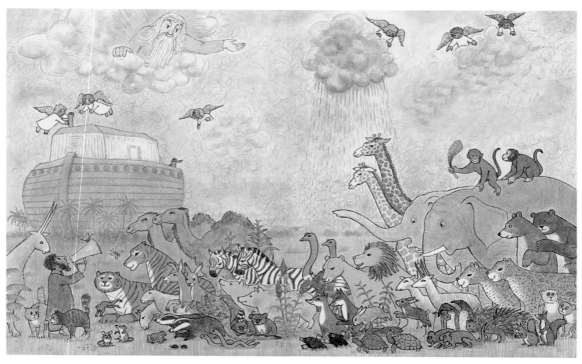

OPPOSITE, ABOVE AND BELOW
Preliminary drawing and finished illustration from *How Mrs Monkey Missed the Ark*, 1992

BELOW
Illustration from *How Mrs Monkey Missed the Ark*, 1992

unlike the basket Mrs Monkey is carrying when she is out gathering last-minute supplies for a long journey in the very funny *How Mrs Monkey Missed the Ark*, 1992).

Unusually for a suburban house, from the high windows one has a completely uninterrupted view of woodland, with mature trees where crows and magpies continually squabble and squawk, pigeons huddle together and squirrels hurtle about from tree to tree. With their branches dramatically silhouetted against the sky, in the crepuscular light of an early winter evening – shades of Arthur Rackham here – it is possible to imagine oneself in the middle of a fairytale forest.

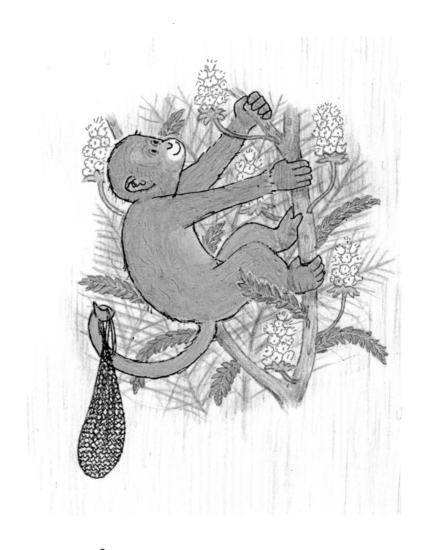

Work after 2006

Kerr and her husband were together for fifty-four years.
In 2004, they celebrated their golden wedding, but Tom was
already seriously ill. Kerr nursed him night and day. And
when he died two years later, Kerr, profoundly affected,
found herself completely unable to work. Even drawing was
out of the question and it would be over a year before she
got going again, initially, after making a Christmas card for
which she used an old drawing – a good likeness – of Tom
sitting at a table, writing.

 There was also a book she had not quite finished –
Twinkles, Arthur and Puss (2007) – a story she had come
across in the local paper about a cat who was fed at three
different households, all of which claimed ownership of it.
Tom had laughed about it and said 'You must do this one'.
She had but it was still incomplete: it needed a few more
balloons. And then suddenly one day, she felt she could

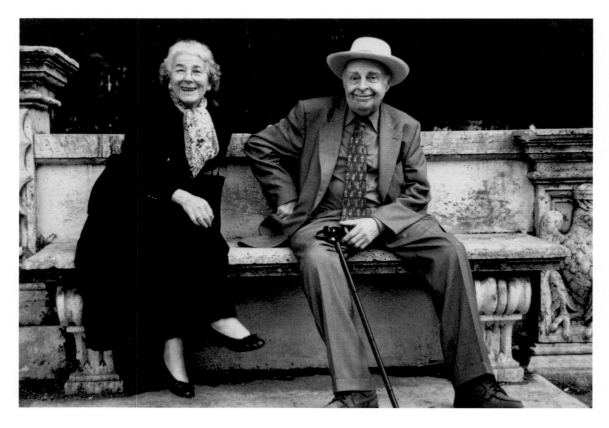

do it, and it was a light-bulb moment: 'I realized that
at least I could still draw balloons!'

A little later she saw some small children playing on the
green after school. Kerr is not a sentimental person – far
from it – but this pastoral scene, with children and a duck
pond, raised her 'visual spirits', as did a visit to the local
restaurant, where she used to go with her husband. There
was a man there, enjoying a solitary meal. The waiter was
pouring a drink, and she found herself watching with that
old intensity, remembering the scene, retaining it, and she
knew she could capture it. Then it was home and back to
the drawing board.

Once again drawing was her lifeline. 'I know who I am
when I'm drawing', she says, and if she is feeling nervous
or anxious it takes her 'to a good place'. It is as if her pencil,
when it touches the paper, completes a circuit, throwing a
switch that lightens her mood and banishes anxiety. Kerr
used to travel a lot but less now given that she is well into
her nineties. She still goes to Rome to see her son and his
family, or to Paris and Berlin to attend literary events, and
she continues to draw, wherever she is. In hotels, if she is

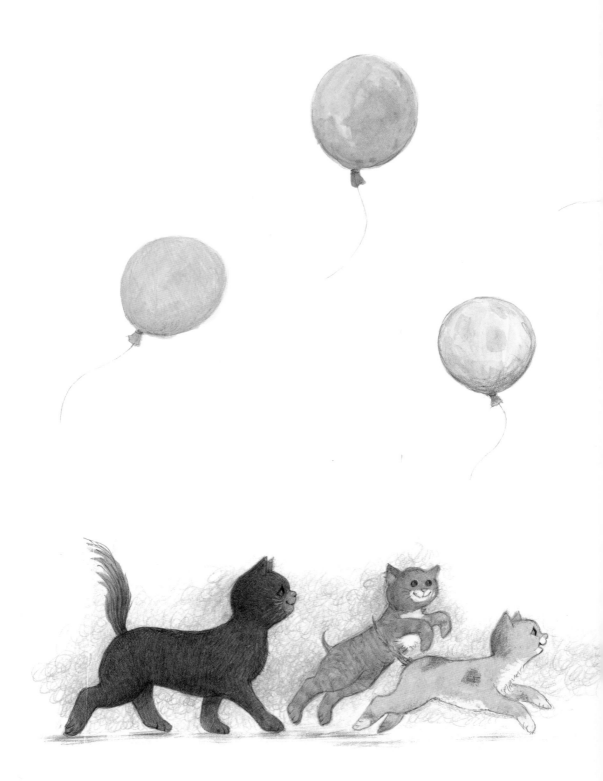

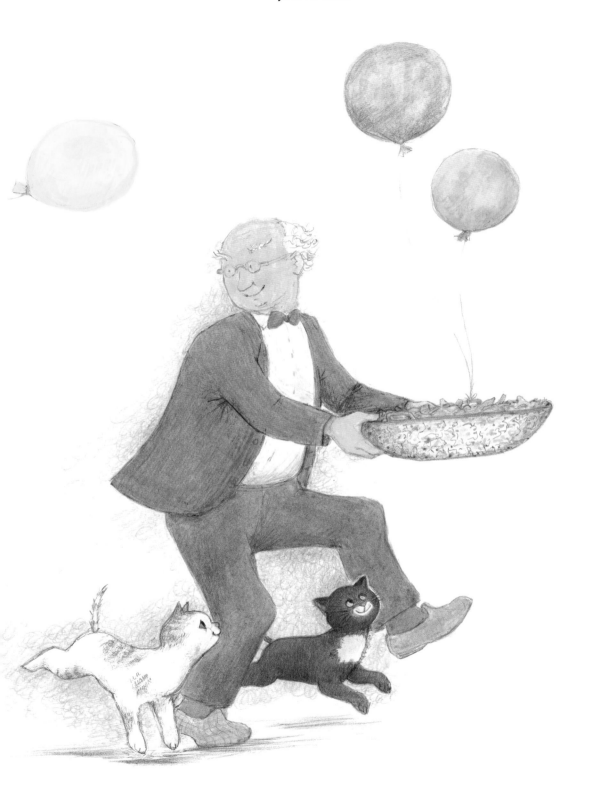

without a sketchbook, she uses 'those little note pads they leave by the telephone – I've probably done some of my best drawings while I've been on the phone'.

One Night in the Zoo, published in 2009, was something of a turning point in Kerr's work. She had been thinking a lot about Marc Chagall and his glorious use of blue; she had been planning to draw a flying elephant, and suddenly, there it was, flying across a double-page spread on a moonlit sky. Instead of a wash she had perfected a way of using pencils and crayons to create a magical night sky with a veil of delicately scribbled loops and bubbles, and colours that moved from deepest indigo and midnight blue to a rosy suggestion of dawn. The elephant was followed on another spread by a crocodile and a kangaroo on a bicycle. There was absolutely no sign of a plot here, things just happened; Kerr had begun to think in pictures. For her it was a liberating experience, but, as a book, she wondered where it was going.

It was Ian Craig who saw what to do. Since 1992, when he joined Collins as art director, Craig has been

BELOW
Illustration from *One Night in the Zoo,* 2009

OPPOSITE, ABOVE AND BELOW
Drawings for *One Night in the Zoo,* 2009

OVERLEAF
Illustration from *One Night in the Zoo,* 2009

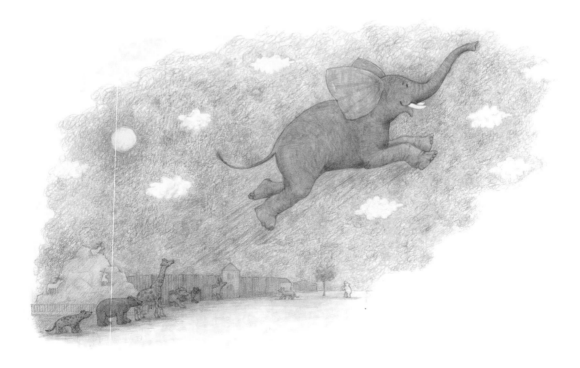

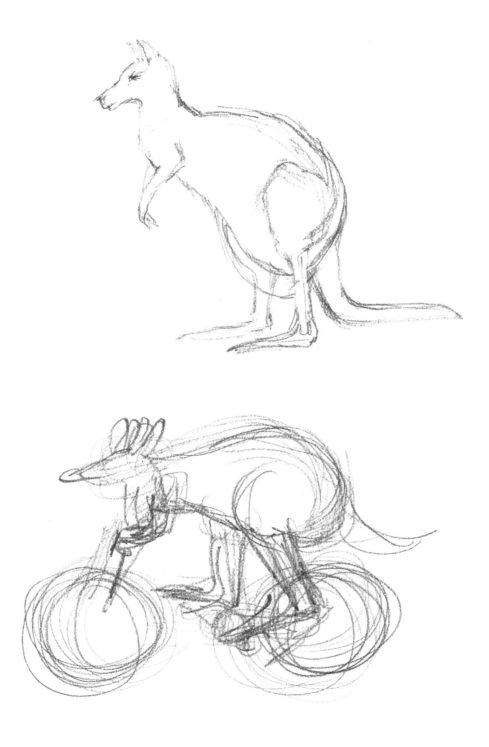

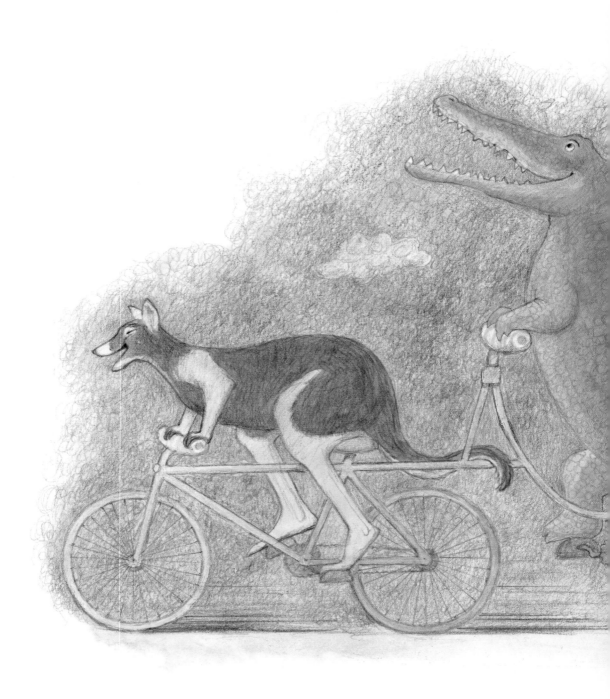

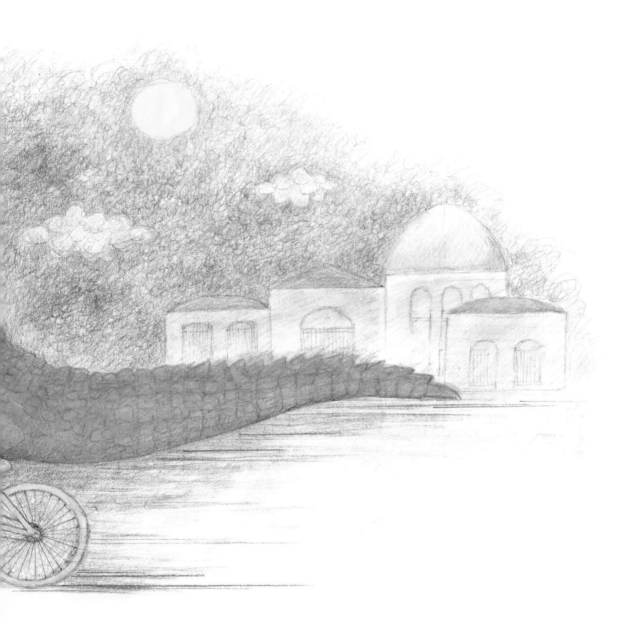

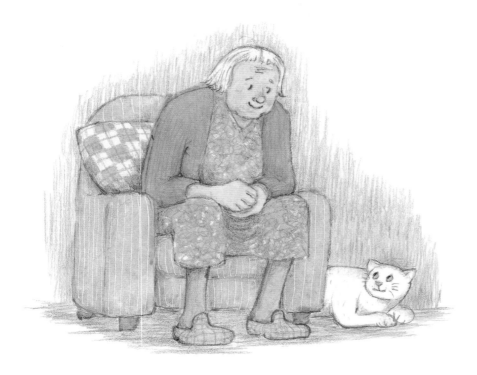

an important figure in Kerr's creative life. A designer
with many years experience, he combines an unlimited
imagination with an authoritative sense of what is possible
on the page. He has worked on many of her books and
although he subsequently moved on from Collins, he has
remained, at Kerr's request, as her own informal art director.
They understand one another and have worked on countless
projects together including the creation of a new unifying
look for the *Mog* series. 'If Ian likes something,' says Kerr,
'then I know it's all right. He has taught me so much.' And
he had the answer as to what to do with the plot-free story
with its freewheeling magic and its easy rhyming text; he
suggested a counting book, a simple solution that made
it work perfectly, neatly sidestepping the problems a plot
might have involved, thereby giving full rein to the poetry
and the lyrical aspect of the illustrations.

 Flying has increasingly added a further dimension to
Kerr's work, and in *My Henry* (2011), a touching love-letter

ABOVE
Illustration from *My Henry*, 2011

OPPOSITE
Edward Hicks, *Peaceable Kingdom*,
c. 1834, National Gallery of Art,
Washington, DC

OVERLEAF
Illustration from *My Henry*, 2011

of a story, it rises to new heights: to Heaven itself. The book opens with a down-to-earth setting, as an elderly widow dozes off in her armchair, dreaming of her Henry, who is now in the 'Great Beyond'. Henry (now with wings) takes her hand and they fly together – two ordinary people – on an out-of-this-world voyage of discovery, seeing wonderful things including mermaids, sphinxes, unicorns and dolphins. They picnic up a tree with a gentle community, reminiscent of the American folk artist Edward Hicks's *Peaceable Kingdom* paintings, where everyone is on equal terms. Even the tiger is there, still drinking his tea straight from the pot. But what the couple like best is a sort of celestial viewing-room where they can enjoy memories from their own life,

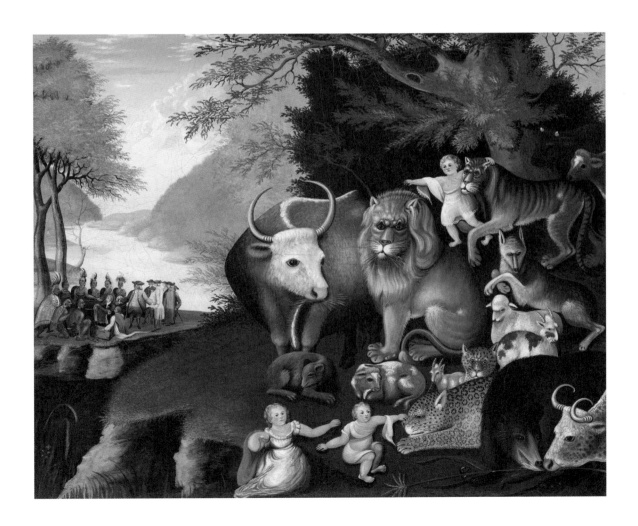

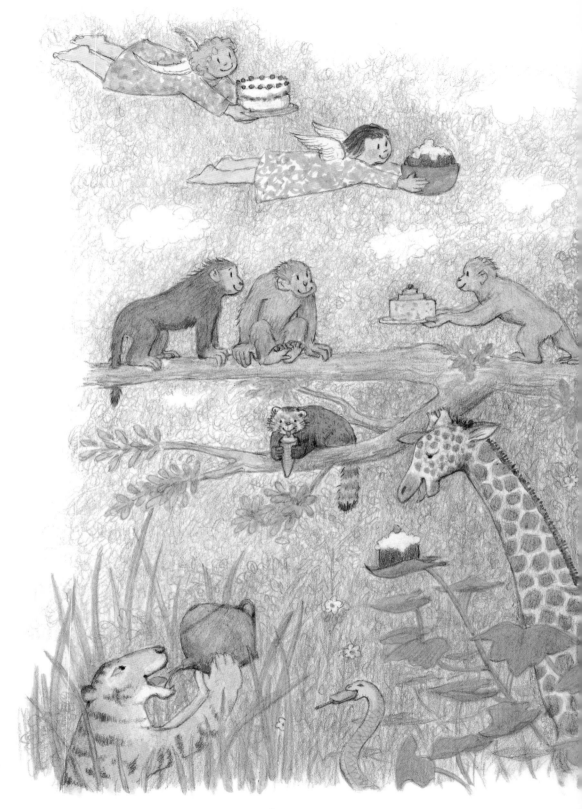

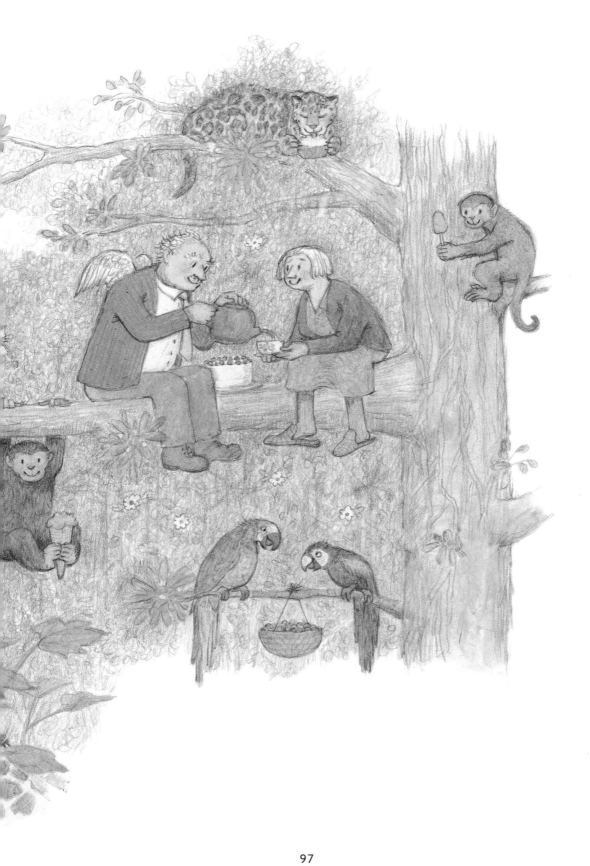

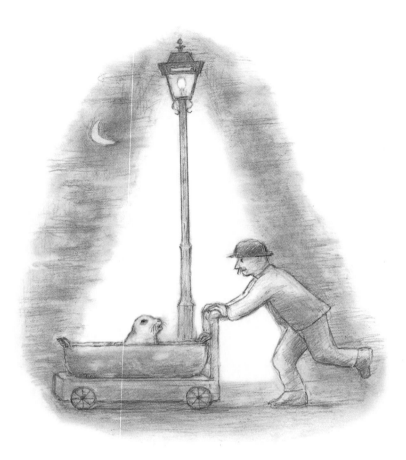

and the time they spent together. This is Kerr's favourite
book among those she has done in an impressive flowering
of new work in her eighties and nineties.

Still exploring different approaches, Kerr illustrated
Mister Cleghorn's Seal (2015) entirely in pencil, which proved
to be the perfect medium for this affectionate, nostalgic
story about a retired shopkeeper who, on a seaside holiday,
rescues a motherless baby seal and keeps it (temporarily)
in a tin bath – something, Kerr explains, her father had once
done. Like the story, the drawings have an accessible, almost
child-like simplicity; the texture of the soft 8B pencil line
and the tonal areas, gently hatched, smoothly rubbed and
shaded, make you feel that if you were to touch the page,
your finger would actually bear traces of the graphite dust.

Kerr is good on pencils; she talks about them like
a sommelier going through the wine list in a restaurant,

ABOVE AND OPPOSITE
Illustrations from *Mister Cleghorn's
Seal*, 2015

with remarks like 'A strong, rich line, but not too dark' (2B) or 'this is a fine encouraging pencil' (4B). She does not use HB, and her favourite is the 8B, an unusually stouthearted pencil. She loves this one; it can do no wrong: 'So soft you can rub it, smooth it, and blend it so easily...it's a really relaxing pencil.'

Pencils have to be a particular length, so that they feel just right in her hand. She favours the Staedtler brand, in their distinctive blue and black livery. Kerr sharpens them meticulously by hand; no fancy electric sharpeners here, just a naked blade. She has always savoured the fragrant woody smell of pencil shavings. Each pencil is regularly sharpened to within a millimetre of its (inevitably short) life, and when it no longer feels right, it takes early retirement, along with all those exhausted rubbers.

With *Katinka's Tail* (2017), Kerr herself is the narrator and is back using graphite and coloured pencils to describe in some detail the touching reciprocal relationship that she enjoys with her very unusual cat. Katinka is white, with a spectacular, richly marked tabby tail. This show-stopping

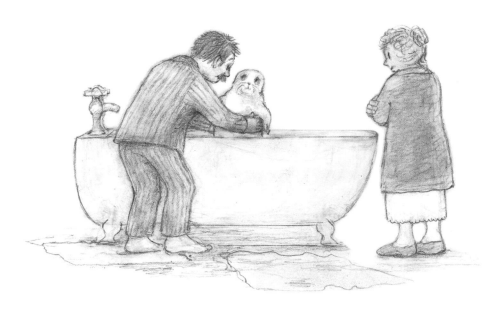

tail has magic powers, able not only to light up at night but also to persuade Ann-Janine Murtagh (the discerning, highly respected executive publisher at HarperCollins Children's Books) to allow generous amounts of costly gold blocking in the illustrations, magically turning the surrounding woodland into a fairytale forest, and giving everyone the ability to fly, including the narrator, who is seen swooping through her bedroom window in dressing gown and slippers.

Since the advent of the Internet, Kerr does not use a sketchbook as much as she once did, but there is still a pile of them in her workroom. Flicking through the pages she muses on the fact that according to Ian Craig her sketchbook drawings often have an 'off-the-cuff' spontaneity that you do not see in her finished artwork. 'Others have said that too. But I don't do spontaneous. I'm no Quentin Blake.' With this, she gets to her feet and does a lightning impression of Blake, making swift, eloquent, mid-air flourishes and

ABOVE AND OPPOSITE
Illustrations from *Katinka's Tail*, 2017

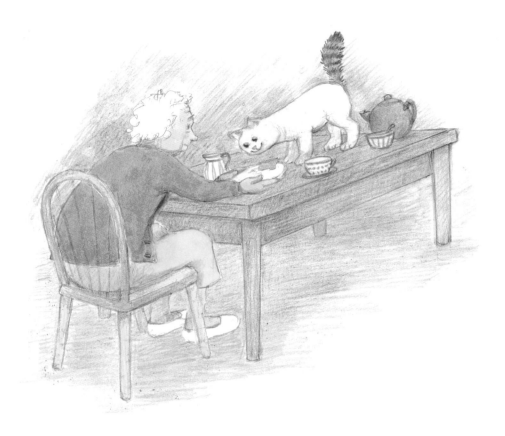

squiggles with an invisible pen. Totally unexpected, the bold freedom of her gestures is reminiscent not just of Blake but also of Pablo Picasso, and those magical photographs of him making drawings in the air with a penlight, taken by Gjon Mili at Vallauris in 1949. There are so many different sorts of magic.

Unlike Blake and Picasso, Kerr's own brand of magic still involves a fair bit of rubbing out. She tends to stare thoughtfully at a line for a while, before gently urging it along, encouraging it…she will then let it run free for a bit, while she thinks. If it starts to run away with itself, she will discipline it, sometimes quite severely, with a rubber. She explains that she has always been a perfectionist, never quite satisfied with what she has done. As a student, she was often teased about the way her face would be covered with pencil dust after all the rubbing-out and redrawing she did in the life classes. Perfectionism is

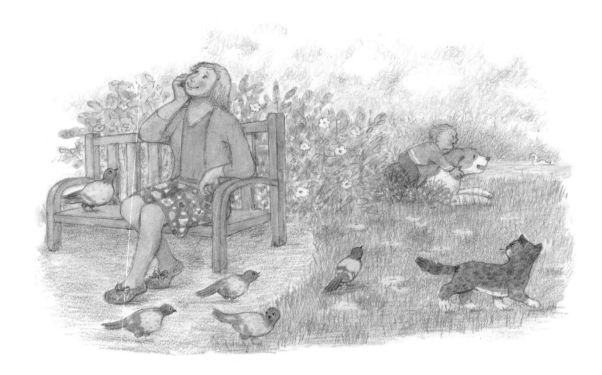

something she inherited from her father. Alfred Kerr was still both correcting and rewriting his own work after it was published – and even after the Nazis had had all his books publicly burnt.

There are now around forty-five Judith Kerr books. Her sales figures are astonishing, way up in the millions, and she has accumulated numerous awards and honours, including an OBE for her services to children's literature and Holocaust education, which, along with the 1974 German Youth Book Prize, is very important to her.

Calm and precise, wise and witty, with a great line in deadpan humour, she is frequently in demand at literary events, anniversaries and award ceremonies. With her hair gleaming like the pearl torque she wears, she is unfailingly elegant and articulate. She handles interviewers and photographers with aplomb: 'I'm no longer nervous as I once was.'

Kerr keeps fit by doing a lot of walking, ideally by the Thames, and it is a good time to think about her current

ABOVE
Illustration from *Mummy Time*, 2018

project. She has her work in mind all the time; even at the dentist she will lie back and plan the layout of two or three pages of her ongoing book. Ideas never stop and given that she is in her mid-nineties one might reasonably expect something of a slowing down, but instead her rate of production has grown considerably. 'My time is my own these days; I can work as late as I want, and I probably do work faster because I've got better at it. I know what I'm doing now – it would be odd, wouldn't it, if after fifty years there was no improvement?' And she frequently has plans for her next book before she finishes the current one.

Mummy Time (2018) was published exactly fifty years after the *Tiger Who Came for Tea* and, showing the same originality, leaps blithely over the conventions of traditional picture-book storytelling. Purposefully making itself accessible to readers both young and old, and indicating that Kerr is up-to-date with contemporary lives, the book tells the story of a young mother taking her small boy out for some exclusive 'mummy time'. Mummy's time, though, is rather unfairly divided between her adventurous toddler and her equally demanding mobile phone. Out in the park, Mummy is constantly talking on her phone to her friend about last night's party, bitterly criticizing the hostess, the guests, the food and the general unfairness of life.

Simultaneously, in witty counterpoint, the illustrations show how the child, free from his mother's attention, is left to his own devices: he eats food thrown for pigeons, befriends a dog, climbs dangerous trees, handles a hairy caterpillar, falls in a lake from which, with an optimistic nod to a classic fairytale ending, he is rescued by a passing swan. Eventually he is joyfully reunited with his mother, who is unaware of his adventures…. There are no recriminations but there is a lot unsaid here, and it is clear that, below the surface, Mummy is having a hard time keeping up.

In her long career, Kerr has seen myriad technological changes. With her non-stop work schedule, what pleases her is that she now has something of a system.

Research is much easier than it was: where once, if she wanted a sneezing tiger (as in *One Night at the Zoo*), she would have had to go to the Zoo and wait indefinitely; with the Internet she can obtain an image immediately.

OVERLEAF
Illustrations from *Mummy Time*, 2018

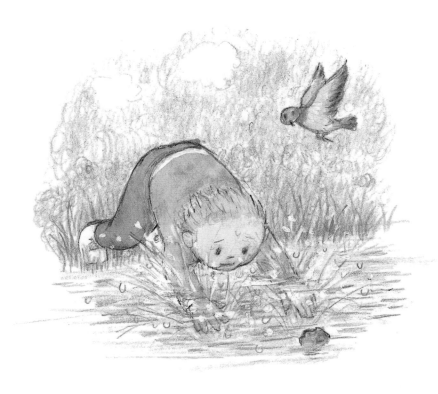

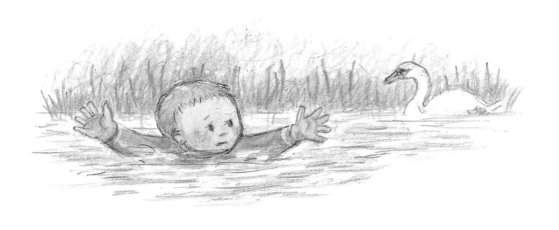

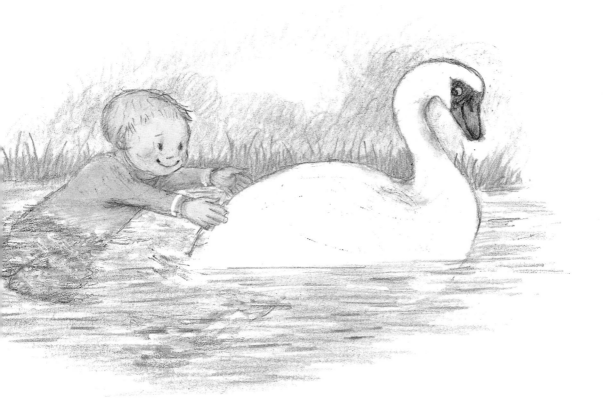

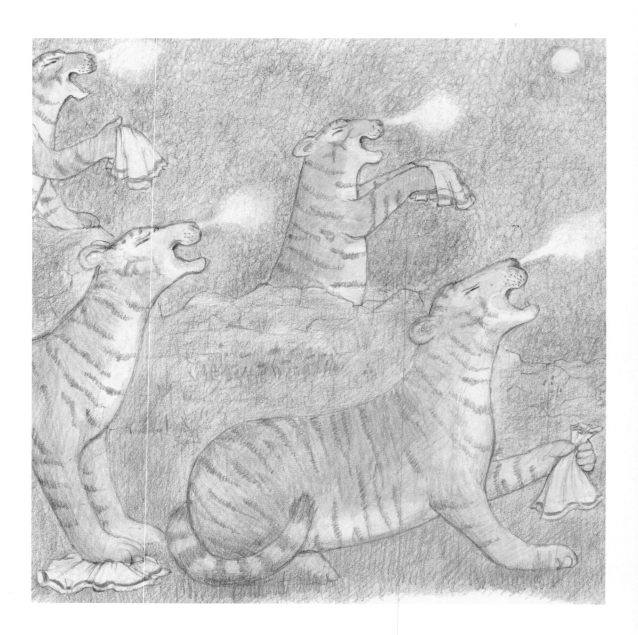

ABOVE

Illustration of sneezing tigers
from *One Night in the Zoo*, 2009

OPPOSITE

Judith Kerr at London Zoo where
she received the BookTrust
Lifetime Achievement Award, 2016

She finds computers are wonderful in other ways, too. If, say, a squirrel is in the wrong place, she can simply get someone in the art department at HarperCollins to reposition it with Photoshop, where once she would have had to draw the whole thing again.

Then there is the question of roughs. She was never in the habit of making proper roughs. 'I just used to get the paper and start drawing, and if it went wrong, start again. It's only fairly recently that I've started doing *proper* roughs *properly* – and keeping them safe in my sketchbook. It took me a long time to realize the importance of this and of course it's made all the difference.'

At the end of a hard day's work, she still remembers her husband's advice: '"Always stop when you know that the next bit is going to be easy," Tom would say. So I always do that, and what's also important for me is that the very *last* thing I do, before I go downstairs, is a rough for the following day. It doesn't matter much what it is, and I may subsequently ignore it, but it means that next morning I'm not going to be confronted with a blank page.'

It is clearly a good system.

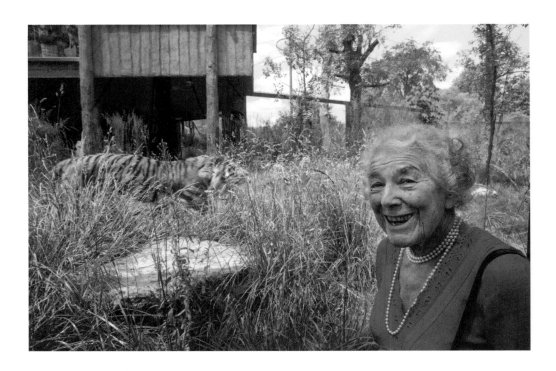

Books written and illustrated by Judith Kerr and published by HarperCollins Publishers Ltd

The Tiger Who Came to Tea, 1968
Mog the Forgetful Cat, 1970
When Hitler Stole Pink Rabbit, 1971
When Willy Went to the Wedding, 1972
Bombs on Aunt Dainty (originally published as *The Other Way Round*), 1975
Mog's Christmas, 1976
A Small Person Far Away, 1978
Mog and the Baby, 1980
Mog in the Dark, 1983
Mog and Me, 1984
Mog's Family of Cats, 1985

Mog's Amazing Birthday Caper, 1986
Mog and Bunny, 1988
Mog and Barnaby, 1991
How Mrs Monkey Missed the Ark, 1992
Mog on Fox Night, 1993
Mog in the Garden, 1994
Mog's Kittens, 1994
Mog and the Granny, 1995
Mog and the V.E.T., 1996
Birdie Halleluyah!, 1998
Mog's Bad Thing, 2000
The Other Goose, 2001
Goodbye Mog, 2002

Goose in a Hole, 2005
Twinkles, Arthur and Puss, 2007
One Night in the Zoo, 2009
My Henry, 2011
The Great Granny Gang, 2012
Judith Kerr's Creatures, 2013
The Crocodile Under the Bed, 2014
Mister Cleghorn's Seal, 2015
Mog's Christmas Calamity, 2015
Katinka's Tail, 2017
Mummy Time, 2018

1923 14 June, Berlin, Anna Judith Gertrud Helene born

1933 On 30 January Hitler becomes Chancellor of Germany. The Kerr family flees first to Switzerland in March and then to Paris in December

1935 Autumn, Judith and her brother, Michael, go to Nice to stay with their maternal grandparents, Robert and Gertrud Weismann

1936 March, their parents take them to London

1938 Attends Hayes Court school, Bromley, Kent

1939 Passes School Certificate and leaves Hayes Court

1940 October, the family is bombed out of its hotel accommodation in Bloomsbury and moves to Putney. Kerr begins secretarial job with a clothing charity

1941 Spring, joins life-drawing evening class at St Martin's School of Art and later studies under John Farleigh at Central School of Arts and Crafts

1945 Awarded a trade scholarship at Central School of Arts and Crafts and works part-time in a textile studio

1947 Becomes naturalized British subject

1948 July, leaves Central School of Arts and Crafts having failed to obtain diploma in book illustration. On 12 October, her father, Alfred, dies

1948–52 Employed as art teacher in various schools

1949 Wins first prize in the Daily Mail Young Artists Exhibition. Prize money finances trip to France and Spain

1952 February, meets Tom Kneale. She becomes a reader of unsolicited plays for BBC television

1954 8 May, marries Tom Kneale

1956 Becomes scriptwriter at the BBC

1957 Her adaptation of John Buchan's *Huntingtower* is broadcast by the BBC

1958 3 January, daughter Tacy born

1960 24 November, son Matthew born

1962 Family moves to a house in Barnes in South London

1965 3 October, her mother, Julia, dies of a heart attack in Berlin, where she had been working as an interpreter since Alfred Kerr died

1968 *The Tiger Who Came to Tea* published

1970 *Mog the Forgetful Cat* published, the first of a series of seventeen books featuring Mog

1971 *When Hitler Stole Pink Rabbit* published

1974 *When Hitler Stole Pink Rabbit* wins Deutscher Jugendbuchpreis (German Youth Book Prize) in the children's book category

1991 With her brother, Michael, she establishes the Alfred Kerr Darstellerpreis (Alfred Kerr Acting Prize) in Berlin, in memory of their father, a well-known theatre critic. The annual award is given to an emerging young actor for outstanding achievement

1992 10 March, a primary school in the Charlottenburg-Wilmersdorf district of Berlin is renamed Judith Kerr Grundschule. It is a bilingual German-French school with walls covered in murals based on Kerr's illustrations

2002 14 April, her brother, Sir Michael Kerr, dies

2002 *Goodbye Mog*, intended as the last of the *Mog* books, published

2006 29 October Tom dies

2006 Second recipient of the Action for Children's Arts Peter Pan Award (subsequently renamed the J. M. Barrie Award), given annually to a children's arts practitioner whose lifetime's work has delighted children

2008 *The Tiger Who Came to Tea* adapted into a 55-minute musical play by David Wood

2011 28 May – 4 September, *The Tiger Who Came to Tea, A Retrospective of Work by Judith Kerr* organized by Seven Stories and held at V&A Museum of Childhood, Bethnal Green, London

2012 March, the production of *The Tiger Who Came to Tea* at the Vaudeville Theatre, London, is nominated in the 'Best Entertainment' category of the Laurence Olivier Awards

2012 Receives an OBE for services to children's literature and Holocaust education

2013 Celebrates her 90th birthday. HarperCollins marks the occasion with publication of *Judith Kerr's Creatures* about her life and work, and in November the BBC broadcast *Hitler, The Tiger and Me*, a television documentary in the *Imagine* strand

2013 Becomes patron of Judith Kerr Primary School, a bilingual English-German primary school in Herne Hill, South London

2015 *Mr Cleghorn's Seal*, her first novel for thirty-seven years, is published

2015 29 June – 14 October, *Tiger, Mog and Pink Rabbit: A Judith Kerr Retrospective* held at the Jewish Museum, London

2015 UK shopping chain Sainsbury's runs an advertising campaign, 'Mog's Christmas Calamity', including a television commercial in which Kerr makes a guest appearance. Profits from the tie-in picture book and Mog toy raise over £1 million for Save the Children UK's literacy campaign

2016 6 July, presented with the BookTrust Lifetime Achievement Award by Michael Morpurgo at a ceremony at London Zoo. She is the second recipient of the award, established to celebrate an author or illustrator's outstanding contribution to children's books

2019 January, wins the Oldie Tigress We'd Like to Have to Tea award at the *Oldie* magazine's annual awards ceremony

2019 7 March, to mark World Book Day, Royal Mail honours Kerr and three other children's authors with a special edition postbox adorned with quotes and images from their work. Kerr's postbox is located in Barnes High Street and decorated for a month

ACKNOWLEDGMENTS

For their help in so many different ways, I would like to thank Claudia Zeff, Julia MacKenzie, Philippa Perry, Beth Coventry, Sarah Lawrance from Seven Stories, Lydia Barram and Hannah Marshall from HarperCollins, and Sadie Carey.

Judith Kerr's archive is held by Seven Stories the National Centre for Children's Books, along with artwork and manuscripts by more than 250 other writers and illustrators. To view the archive, please contact collections@sevenstories.org.uk.

PICTURE CREDITS

CONTRIBUTORS

Joanna Carey is a writer, illustrator and reviewer. She originally trained as a painter and spent many years as an art teacher in a number of London schools and pupil referral units. She has written about children's literature in a variety of publications and in the 1990s she was the *Guardian* children's books editor for five years.

Quentin Blake is one of Britain's most distinguished illustrators. For twenty years he taught at the Royal College of Art where he was head of the illustration department from 1978 to 1986. Blake received a knighthood in 2013 for his services to illustration and in 2014 was admitted to the Légion d'honneur in France.

Claudia Zeff is an art director who has commissioned illustration for book jackets, magazines and children's books over a number of years. She helped set up the House of Illustration with Quentin Blake where she is now Deputy Chair. Since 2011 she has worked as Creative Consultant to Quentin Blake.